Christopher Wright

FRANS HALS

PHAIDON

Phaidon Press Limited, Littlegate House, St Ebbe's Street, Oxford
Published in the United States of America by E. P. Dutton, New York

First published 1977

© *1977 Elsevier Publishing Projects SA, Lausanne/Smeets Illustrated*
Projects, Weert

ISBN 0 7148 1750 3
Library of Congress Catalog Card Number: 77-73887

Printed in The Netherlands

FRANS HALS

It is only during the last hundred years that Frans Hals has been recognized as a great painter. Although esteemed by his contemporaries in the seventeenth century, he never achieved the affluence or the reputation of Gerard Dou in nearby Leiden, or of Bartholomeus van der Helst in Amsterdam.

In the late nineteenth century, however, Hals's free brushwork began to be appreciated, and many of his pictures were brought out of the relative obscurity in which they had been for the previous two centuries. It became fashionable for millionaires to own single portraits by Hals, and many of his best pictures of this type ended up on the walls of the houses of the newly rich – Charles Phelps Taft in Cincinnati, Henry Clay Frick in New York, and Frank P. Wood in Toronto. It was this wave of appreciation which caused the *Laughing Cavalier* (Plate 9) to achieve such sudden fame.

A balanced view of Hals was, however, impossible in the late nineteenth century. That most perceptive of critics, Eugène Fromentin, found himself unable to appreciate the painter's late free style, especially the last group portraits at Haarlem. It remains true that Hals's art cannot really be understood outside Haarlem, where there are eight out of the nine large group portraits which he painted. The ninth, which was left incomplete by Hals and finished by Pieter Codde, is in the Rijksmuseum, Amsterdam.

Together at Haarlem the group portraits form a corpus of paintings by one artist which is unique in Dutch seventeenth-century art, as the works of most other painters cannot be seen together in one place. There are over eighty portraits in these eight pictures, representing almost one third of Hal's surviving output, as it is now believed by scholars and connoisseurs that only some two hundred single portraits survive from his hand.

For a painter whose style was so free and whose brushstroke so rapid, this is a relatively small output for a career of over sixty years. There is no doubt that Hals was enormously prolific, and it is likely that many of his works were simply discarded by later generations who found them too sketchy. This possibility is strengthened by the fact that very few of Hals's pictures can be traced back as far as the seventeenth century, for the history of many of them begins in the early nineteenth century.

The Haarlem group portraits have not always been appreciated as they are now, and the changing critical attitude towards them shows that a painter's reputation is a very fragile thing. Each generation reinterprets the art of the past, and Hals's style is so personal that his art easily fell victim to neglect, and even ridicule, when critics turned against freedom of brushwork. The reputation of the *Laughing Cavalier* is a good example. Once in every schoolroom, once having had endless romantic stories woven around it – the man is not laughing but the eyes are – the picture is now subjected to patronizing neglect. But in his recent work on Hals, the art historian Seymour Slive has studied the picture again most carefully, divesting it of its romantic and popular adornments, and points out that it is still a masterpiece of portraiture.

In order to justify Hals's greatness as a painter of portraits – little else survives from his hand – he must be shown to have been above his contemporaries and to have made his own contribution to the art of the portrait. A general history of the development of portrait painting would perhaps leave Hals a little to one side. It was Rembrandt who

made fundamental changes to the art of portraiture, by observing the deeper side of human nature. It was Rembrandt, too, who adopted the warmth and richness of Venetian colouring, especially that of Titian, and made it his own.

None of this applies to Hals. He belonged to no such tradition. As a child he could have been familiar with the severe portrait style practised in Antwerp in the last years of the sixteenth century, and some of his early portraits have an austerity and extensive use of black which is a reminder of the art of that century, and especially of the portraits by Anthonis Mor. An example of this type is the *Man Holding a Skull* in the Barber Institute at Birmingham. This picture makes not the slightest concession to any charm the sitter may have possessed; instead, the man is painted with a slight frown, and the feeling is almost hieratic. Rather than observing the lessons of the Italian Renaissance, which had evolved a perfect series of formulae for the painting of portraits – formulae which were to continue right down to the nineteenth century – Hals went his own way and built on the scanty local traditions, developing his own completely individual type of portrait. It would seem that he looked at the work of other painters hardly at all. Early sources say that he was taught by the mannerist painter Carel van Mander, but it is not possible to detect Van Mander's influence even in Hals's early work.

Hals also took little notice of the enormous amount of painting activity which was taking place around him in Haarlem. Borrowings from other painters are hard to find. An isolated example is his use of the composition of Cornelis van Haarlem's *Group Portrait* of 1599 (Haarlem, Frans Hals Museum) as the basis for his own first group portrait of the *Banquet of the Officers of the Civic Guard Company of St George* of 1616 (Plate 1). There were many experimental painters in Haarlem, especially in the second and third decades of the century. Pieter Claesz. and Willem Claesz. Heda, the still-life painters, and the inventive group of landscape painters which included Pieter de Molyn and Esaias van de Velde, all began at precisely the time that Hals was feeling his way. The St George Company group portrait is still immature as an integrated composition, although each individual head is brilliantly observed. The real changes in Hals's art took place in the 1620s, when the stiff and formal qualities of the early style disappeared. The portraits became much more elaborate, and resulted in two exceptional pictures – the *Laughing Cavalier* of 1624 (Plate 9), and the first portrait of *Willem van Heythuyzen* (Munich, Alte Pinakothek), of about the same time.

Hals was never more controlled than during this period. Elaborate lace details seem as if they were sought out, as if the artist were looking for an excuse to paint them. It is too easily forgotten that most connoisseurs of painting, with the signal exception of those of the present day, could take quite innocent pleasure from the meticulous painting of a sleeve (see Plates 5 and 7). The imaginative painting of detail for its own sake is today mistrusted, but this is the key to Hals's best portraits of these years.

In fact the *Laughing Cavalier* is a high point of technical achievement and marks the beginning of a totally different trend. Hals was starting to concentrate on the dazzle of brushwork for its own sake. The loosening of his brushwork was amazingly rapid. In the portrait of *Isaac Abrahamsz. Massa* (Plate 14), painted only two years after the *Laughing Cavalier*, the characteristic rapid strokes and the suppression of detail are already visible. These characteristics were to persist, becoming ever more free, for the remaining forty years of his life.

In 1627 Hals painted two more large group portraits (Plates 11 and 12), which are much more relaxed in mood than the first one of eleven years before. They are totally original in composition, and their very liveliness, especially in the treatment of the individual heads, coincides with his interest in the painting of heads of peasants, musicians

4

and fisher-children. The handling of these low-life pictures is quite different from that of the more formal portraits, and they foreshadow in a curious way the approach he was to use for small portraits right at the end of his life.

The low-life pictures fall into two categories. Firstly the fisher-children, which are often painted with a suggestion of a landscape in the background. This is the type of Hals painting which has most frequently been subjected to doubts by modern historians, but it appears quite consistent in handling with the second category of low-life picture. These are usually a little larger in format, and include some of Hals's best known compositions: the *Merry Drinker* (Plate 19), the *Gipsy Girl* (Plate 23), and *Malle Babbe* (Berlin-Dahlem, Staatliche Gemäldegalerie). It was this aspect of Hals's art which was the most imitated by those around him in Haarlem. They could grasp his approach to peasant genre painting, but could never understand his portraiture.

The changes which took place in Hals's art from the intensely active period of the 1620s to the last great outburst of creativity in the 1660s are difficult to chart. He seems to have oscillated between the severely formal portraiture of the type of the husband and wife in Edinburgh (Plates 30 and 31) and a much less stiff approach, as in the second of the two portraits of *Willem van Heythuyzen* (Brussels, Musées Royaux des Beaux-Arts). Van Heythuyzen is shown seated informally, leaning back on his chair, and the whole is loosely painted with almost the same bravado as *Malle Babbe*.

Hals painted his last militia portrait in 1639—the *Officers and Sergeants of the Civic Guard Company of St George* (Haarlem, Frans Hals Museum). Unusually the figures are placed in a straight line; the usual vibrant colour of his militia portraits is there, but the picture is evidence of his loss of interest in compositional experiment at this stage in his career. The change is seen quite dramatically in the group portrait of the *Governors of the Hospital of St Elisabeth at Haarlem* (Haarlem, Frans Hals Museum), painted only two years later. It is still a conversation piece, in the sense that the sitters are aware of each other's presence, but all the bright colour and the feeling of movement which characterized the militia portraits have disappeared almost entirely.

Throughout the 1640s and 1650s Hals's portraits became much more stereotyped in their superficial characteristics. Most of his sitters were middle-aged, with a roughly equal balance between men and women. He painted no more fisher-boys, gipsy girls or militia groups. Instead, he concentrated on a penetrating analysis of each sitter. Contrary to what is often said, Hals was unusually perceptive about the character of people, mostly from the middle walks of life, neither very rich nor very poor. He did have one very famous sitter during this period – *René Descartes* (Copenhagen, Royal Museum). This tiny picture, sketchy like the Heythuyzen portrait, may have been commissioned from Hals by one of the great philosopher's friends.

In these rather formal portraits of the 1640s and 1650s Hals recorded in a matter-of-fact way the sitters' black clothes, but gave life to their faces. What he saw in his sitters' faces was not always pleasant, any more than a gathering of the burgomasters of Haarlem to discuss municipal expenditure would have been a good-humoured event. The danger for most critics has been the over-interpretation of Hals's powers of observation by seeing him as a ruthless exposer of human foibles. In fact this is not quite what he did. He painted the disarming smile of the gentle lady in the museum at Hull (Plate 40), or the portly and pretentious matron in the picture at Christ Church, Oxford (Plate 38), exactly as they appeared to him and without any moral overtones.

When required to paint people from a grander walk of life, as in the *Portrait of Isabella Coymans* (Plate 35), Hals seems to have observed the character less deeply, and concentrated, as he had done earlier in his career, on the minutiae of her finery.

Hals's last years revealed a new interest in the qualities of honesty and directness. His images lack everything which makes Rembrandt's late style so much admired. Rembrandt's portraits, especially his self-portraits, show suffering with dignity. Hals had no such illusions, and many of his sitters' faces are flaccid, bleary-eyed and disgruntled, as in the *Portrait of Tyman Oosdoorp* (Berlin-Dahlem, Staatliche Museen), where the mouth is very definitely turned down at the corners.

Hals was able, in his last years, by constantly looking at people, to acquire the skill and experience necessary for the production of his two great group portraits, the *Regents* and *Regentesses of the Old Men's Almshouse, Haarlem* (Plates 42 and 43). These two pictures have been subjected to a vast amount of critical interpretation. Neither is easy to appreciate. Hals observed these two august groups of elderly people at their deliberations, but placed them in frontal poses. There is no real attempt at a conversation piece, but they appear to be a series of single portraits side by side. This is what makes the impact. In most group portraits, and in all those by Hals with this one exception, some sitters are discreetly played down, either in tone, expression or colour, in order to integrate them satisfactorily into the group. But in these two pictures there are no such concessions: each sitter is given equal emphasis and prominence. The spectator is thus disconcerted by eleven exceptionally powerful portraits in two pictures.

The technique, too, is quite astounding. There is rapid brushwork on the cuffs and collars, but most of the picture surface is of a dense black of a peculiar impenetrability. There is none of the effect of life and brilliance seen in the militia groups, but instead we sense the quivering hands, the bleary eyes blinking, the mutterings about questions of finance, and the indomitable gazes of men and women who have had seventy years of having their own way.

Even though the *Regents* portraits are acknowledged to be among the greatest ever painted, there is always a doubt in people's minds about the real stature of Hals. There is a mistrust of his directness, or a lack of sympathy with the type of people he painted. But the problem does not end there, because Hals was responsible, especially in his last years, for the evolution of a personal technique which was to have an important influence in the nineteenth century, especially on Manet, Whistler and Sargent.

By contrast, Rembrandt often softened his rapid brushwork and heavy impasto with layer upon layer of transparent glazes, especially in such celebrated passages as the sleeves in the *Jewish Bride* (Amsterdam, Rijksmuseum). Hals worked in precisely the opposite way. He laid on the paint with single clean strokes and then left it. This meant that each stroke had to be accurate. He could not bring the whole together with an amber glow concealing the odd mistake in drawing. This totally uncompromising way of painting pictures means that his portraits often seem rather brittle. They do not have depth. His faces do not live in harmony with their backgrounds, and sometimes it is as if his people were made of pieces of sharp stone and glass instead of flesh and blood. They do not emerge imperceptibly from the shadows, as in Rembrandt, but jump out at the spectator in a quite disconcerting three-dimensional way. Hals liked to paint hands as if they were pointed right at the spectator, as in the *Boy with a Skull* (Plate 8), or to make the sitter smile straight out of the picture, as in the *Portrait of a Woman* (Plate 40).

In the final analysis, Hals's real position in the hierarchy of great painters is a matter of taste. His importance in his own time was considerable – he was still the most influential painter in Haarlem, even if he was not the most successful. He suffered a couple of centuries of comparative neglect, only to be over-admired during the excitement of rediscovery in the late nineteenth century. The twentieth century has produced a more balanced view. Scholarship has now revealed the full extent of his work by adding many of

6

the low-life scenes neglected in previous years, and it is now possible to be familiar with Hals's full range in a way denied to earlier generations. But this has not made the position any easier. Academic knowledge of a painter's range does not always lead to understanding. When too many of Hals's pictures are put together in an exhibition or the pages of a book he may be thought to be repetitive. Modern taste expects a painter to be constantly inventive. Hals was remarkably single-minded and worked within a very narrow vocabulary of blacks, ochres, earth reds and white. He observed his contemporaries without romanticism. His genius forces itself on the spectator in brief flashes – in a smile, in a glance, or, most movingly, in the gazes of those aged *Regents* and *Regentesses* at Haarlem.

In the following notes references are given to catalogue numbers in Seymour Slive's three-volume work *Frans Hals* (London, Phaidon Press, 1970–4).

Plate 1. *Banquet of the Officers of the Civic Guard Company of St George.* 1616. Canvas, 175 × 324 cm. Inscribed with the date on the arm of the chair at the left: 1616. Unsigned. Slive No. 7. Haarlem, Frans Hals Museum.

This picture is the earliest of the five large group portraits of militia companies which Hals painted. There was an existing tradition in Haarlem of group portrait painting even before Frans Hals arrived as a young man in the 1590s. Two of them survive from the hand of the Haarlem mannerist Cornelis van Haarlem. The earlier of these is dated 1583, and the second one of 1599 (both Haarlem, Frans Hals Museum) was the source used by Hals for the composition of this picture. He gave the picture a totally different feeling from that of his predecessor, making the whole less formal and concentrating on the lively expression of each sitter. The beautifully painted still-life on the table anticipates the work of such Haarlem still-life painters as Pieter Claesz., who arrived in the town some three years after this picture was painted.

Plate 2. *Ensign Jacob Cornelisz. Schout.* Detail from the *Banquet of the Officers of the Civic Guard Company of St George* (Plate 1).

Plate 3. *Ensign Jacob Cornelisz. Schout, Captains Nicolaes Woutersz. and Vechter Jansz., and Lieutenant Cornelis Jacobsz. Schout.* Detail from the *Banquet of the Officers of the Civic Guard Company of St George* (Plate 1).

Plate 4. *Nurse and Child.* Canvas, 86 × 65 cm. Unsigned. Probably painted about 1620. Slive No. 14. Berlin-Dahlem, Staatliche Museen.

In the early part of his career, the artist's interest in the painting of lace and embroidery became almost an obsession, which culminated in the *Laughing Cavalier* of 1624 (Plate 9). Although he shows a certain interest in the relationship between the nurse and the rosy-cheeked and contented-looking child, his real skill is lavished on the child's embroidered dress and the lace trimmings. Yet even in these early pictures, however complicated and intricate the design, the artist is at pains to retain the unity of tone and colour.

Plate 5. *Portrait of a Man with Folded Arms.* Canvas laid down on panel, 107 × 85 cm. Inscribed upper left: AETAT SVAE 36. Inscribed upper right: ANO 1622. Unsigned. Slive No. 18. Chatsworth, The Duke of Devonshire and the Trustees of the Chatsworth Settlement.

Hals very rarely seems to have dated his pictures, and it is perhaps surprising that this sober portrait was painted only two years before the *Laughing Cavalier* (Plate 9). Instead, the style of the picture is much more closely related to the Berlin *Nurse and Child* (Plate 4),

especially in the handling of the sleeve, which is almost identical with that of the child's dress in the Berlin picture. As is the case with so many of Hals's portraits, the sitter has not been identified, and although a likeness to Isaac Abrahamsz. Massa has been suggested, the resemblance is quite superficial (see Plate 14).

Plate 6. Detail from *Nurse and Child* (Plate 4).

Plate 7. Detail from the *Laughing Cavalier* (Plate 9).

Plate 8. *Boy with a Skull*. Canvas, 92·2 × 80·8 cm. Unsigned. Probably painted about 1626–8. Slive No. 61. Private Collection.

In the nineteenth century this picture was romantically identified as a portrait of Hamlet, in the scene where he is lamenting over the skull of his lost friend, Yorick. Modern scholarship has sadly dispelled this myth, replacing it by the much more convincing possibility that the picture was intended as a *Vanitas* – a warning to youth of the transience of life. The precise meaning is not clear, as Hals also painted a stern old man holding a skull (Birmingham, Barber Institute), and the skull may have either a general meaning as a symbol of death, or possibly some personal meaning to the sitter.

In few of his other pictures is Hals so daring both with the brushwork and the perspective. The youth's hand, thrust out towards the spectator, is an astonishing piece of sheer technical skill.

Plate 9. *The Laughing Cavalier*. Canvas, 86 × 69 cm. Inscribed in the upper right-hand corner: AETA SVAE 26 A⁰ 1624. Unsigned. Slive No. 30. London, Wallace Collection.

This famous picture, mistitled like many famous pictures, in spite of over-exposure through every known medium of reproduction, is still one of the best-known works by any 'Old Master'. The magic of the laughing eyes and the composed mouth form an easy starting-point to the painting's universal appeal.

Until recently, however, the picture has not received the historical study it deserves. The sitter remains unidentified, and must be presumed to be some successful young soldier of the type which looks so different when seen merry-making in a barrack-room scene by Willem Duyster or Pieter Codde, both of whom were followers of Hals, working in Haarlem and Amsterdam.

Plate 10. *A Couple in a Garden*. Canvas, 140 × 166·5 cm. Unsigned. Probably painted about 1622. Slive No. 17. Amsterdam, Rijksmuseum.

An immense variety of approach characterizes Hals in the 1620s, and here he has chosen to place his sitters at ease under a tree in a spacious garden, just as Rubens had done when he painted himself with his first wife, Isabella Brant (Munich, Alte Pinakothek). The happy couple look as if they are enjoying a joke, so cheerful are their expressions. The mood is continued in the background, and it may be that this really is one of the rare pieces of landscape by Hals himself, for the landscapes in his pictures are often by other artists (see also the two other family groups, Plates 32 and 33).

Plate 11. *Banquet of the Officers of the Civic Guard Company of St George*. 1627. Canvas, 179 × 257·5 cm. Unsigned. Slive No. 46. Haarlem, Frans Hals Museum.

It was a remarkable feat for Hals to paint two large militia company pieces in one year – this and the St Hadrian group (Plate 12). They differ from one another more in the composition than in the handling of the paint. In the St George group there is less interest in putting the figures into the context of the background. Instead, they are rather artificially placed against a curtain, which makes the whole look much more posed than the St Hadrian group. All the painter's efforts have been concentrated on the facial

8

expressions of the eleven sitters, all of whom are in different poses. Their expressions are so lifelike that they invite speculation as to their real characters, and it would be possible to make up, as nineteenth-century historians loved to do, a little story round what they might be saying to one another, as they indulge in a bout of eating and drinking.

Plate 12. *Banquet of the Officers of the Civic Guard Company of St Hadrian.* 1627. Canvas, 183 × 266·5 cm. Signed in monogram on the chair at the left: FHF. Slive No. 45. Haarlem, Frans Hals Museum.

This group portrait represents Hals's most conscious effort to create a convincing interior scene. The whole is very pale in tone compared with all the other group portraits, and the tinted glass window at the back subtly changes all the colours in the picture. The composition is especially full of incident, for example, the man second from the left pointedly holds down his empty glass, and the seated figure in the centre has his knife poised ready to cut the meat. As in most of Hals's group portraits, the colours are basically black, white, earth red and ochre, enlivened by the brilliant crimson and amber of the military sashes.

Plate 13. *Captain Willem Warmont and Lieutenant Matthijs Haeswindius.* Detail from the *Banquet of the Officers of the Civic Guard Company of St Hadrian* (Plate 12).

Plate 14. *Isaac Abrahamsz. Massa.* Canvas, 80 × 65 cm. Inscribed and dated on the right-hand upright of the chair: AETA 41 1626. The authenticity of this inscription has been doubted. Slive No. 42. Toronto, Art Gallery of Ontario.

Modern taste tends to regard this picture, rather than the *Laughing Cavalier*, as Hals's masterpiece of single portraiture from the 1620s. It has all the directness, liveliness and intensity which is so admired in his work, without the elaborate artifice of the *Laughing Cavalier*. The sitter has been identified because another portrait of him, later in life (San Diego, Fine Arts Gallery; Slive No. 103), was engraved soon after it was painted. Slive describes Massa (1586–1643) as 'merchant, historian, geographer and cartographer', but it would be difficult to guess that the sitter had such varied interests by looking at Hals's interpretation of him. It has been thought that the landscape background was painted by Pieter de Molyn, the Haarlem landscape painter, but if this is so, Molyn modified his style to fit in perfectly with Hals's brushwork.

Plate 15. *Captain Nicolaes Verbeeck.* Detail from the *Banquet of the Officers of the Civic Guard Company of St George* (Plate 11).

Plate 16. *Two Laughing Boys* (detail). Canvas, 69·5 × 58 cm. Signed in monogram on the right above the jug: FH. Probably painted 1626–8. Slive No. 60. Leerdam, Hofje van Aerden, on loan to Rotterdam, Museum Boymans-van Beuningen.

There was a side of Hals's character which enabled him to paint low-life scenes quite different in feeling from his austere and dignified portraits of burghers. Here the expression is one of coarse laughter. The boy in this detail is holding a jug and has probably just drunk its contents. In recent years different meanings for the picture have been put forward. It has been thought to be one of the Senses (Sight), or a secularized version of one of the Seven Deadly Sins, Gluttony. But quite obviously, whatever the real meaning of the picture, the boy with the jug is up to no good, and the painting is one of the best examples of this type of low-life picture.

Plate 17. *Pieter van den Broecke* (detail). Canvas, 71·2 × 61 cm. Unsigned. Probably painted in 1633. Slive No. 84. London, Kenwood House (Iveagh Bequest).

The sitter's identification is secure, owing to the fact that the composition was engraved as the frontispiece to the published journal of Van den Broecke's travels in the East Indies,

which appeared in 1634. The caption to the engraving reads that the sitter was aged 48 and it is dated 1633. Van den Broecke (1585–1641) was a trader who worked all over the wide area of Dutch trading interests – Africa, Arabia, Persia and India – and Slive notes that his writing 'reveals a warm straightforward man, who must have been a good talker'.

From the point of view of style, the handling is already very free, and the rapid brushwork, especially in the painting of the hair and the hands, anticipates the late period.

Plate 18. Detail from *A Couple in a Garden* (Plate 10).

Plate 19. *The Merry Drinker.* Canvas, 81 × 66·5 cm. Signed in monogram right: FH. Probably painted about 1628–30. Slive No. 63. Amsterdam, Rijksmuseum.

This picture is generally dated at the end of the 1620s, and it shows how far Hals had developed away from the precise style of the *Man with Folded Arms* (Plate 5). Here, the whole is freely painted over a brown-toned ground, which is allowed to set the dominant colour of the picture. There is almost no modelling in the conventional sense, and the three-dimensional impression is given by the use of sharp accents of light and dark. The result is a tremendous feeling of life – the sitter's mouth is half open as if he is about to speak. He should perhaps be rechristened the *lively* drinker, as there is an undertone of sadness behind the merriment.

Plate 20. *Ensign Adriaen Matham.* Detail from the *Banquet of the Officers of the Civic Guard Company of St Hadrian* (Plate 12).

Plate 21. Detail from *The Merry Drinker* (Plate 19).

Plate 22. *Portrait of a Man in his Thirties.* Canvas, 64·8 × 50·2 cm. Signed in monogram centre right: FH. Inscribed below the monogram: AETAT SVAE 3(?) ANO 1633. Slive No. 81. London, National Gallery.

The feeling of slight awkwardness is caused by the fact that the picture has been cut on the right, removing in the process the last digit of the sitter's age. The picture was long thought to be a pendant to the *Portrait of an Unknown Woman* (Plate 29), also in the National Gallery, London, although they differ in the handling of the paint.

The sitter of this happy portrait appears to have a gentle and kindly disposition, and the whole picture has a greater intimacy than is often found in Hals's portraits of this type.

Plate 23. *Gipsy Girl.* Panel, 57·8 × 52·1 cm. Unsigned. Probably painted about 1628–30. Slive No. 62. Paris, Musée du Louvre.

This brilliant picture is perhaps too often selected by anthologists as typical of Hals's work. In fact its extreme low-life frankness is unusual, as it is in the equally celebrated and brilliant *Malle Babbe* in Berlin (Slive No. 75). In the 1620s Hals was preoccupied with the depiction of laughter, and he painted a number of small pictures of children laughing. But the *Gipsy Girl* is depicted with a wicked smile, as if she were a temptress.

The technique of this picture is especially interesting. The painter has used the grain of the wooden panel to give the surface its texture, and the whole picture is very thinly painted, allowing the brown tone of the wood, or a thin priming of a similar colour, to show through.

Plate 24. *Laughing Fisher-boy.* Canvas, 82 × 60·2 cm. Signed in monogram on the jug: FHF. Probably painted in the late 1620s. Slive No. 55. Rotterdam, Museum Boymans-van Beuningen.

Hals painted a number of pictures of fisher-boys and fisher-girls, although modern scholars are not satisfied that all of them are authentic. Almost all the authorities, except Slive, have tended to reject this and several other related pictures. However, the

technique is quite in keeping with other pictures certainly by Hals dating from the 1620s, and it would not be easy to find another Haarlem painter of this calibre to whom the fisher-children could be attributed. Such children must have been a common sight on the beaches and in the fishing villages near Haarlem, and Hals responded to their natural jollity.

Plate 25. *Portrait of an Unknown Woman.* Canvas, 83·4 × 68·1 cm. Unsigned. Probably painted about 1635–8. Slive No. 112. London, National Gallery.

It is often forgotten that Hals was supremely good at painting formal portraits as well as the more intimate type. (His preference for the latter may have been the cause of his financial problems, as the sitters may not always have been happy to be seen so frankly.) Here Hals has retained a stiff formal pose for this rather prim old lady, whose identification is not certain. She appears to be dressed in her very best clothes, and must have belonged to the merchant classes.

Plate 26. *Officers and Sergeants of the Civic Guard Company of St Hadrian.* 1633. Canvas, 207 × 337 cm. Unsigned. Slive No. 79. Haarlem, Frans Hals Museum.

This is the fourth in the sequence of five militia company group portraits which Hals painted, and it is generally dated 1633. Hals is more ambitious here than in the earlier pictures in that he includes a larger number of figures, and integrates them with each other in a very subtle way, even though they are placed in a long line. This is achieved by various methods. Firstly, some are seated and others standing, which produces a variety of silhouettes. Secondly, the halberds and flags in the background occur at strategic intervals, and the coloured sashes, mainly ice blue, deepest amber and red, break up the basic harmony of black and white. The handling of the paint is especially dazzling, but nowhere does the brushwork take over for its own sake. There is also the essential preoccupation with the character of each sitter. Especially intense is the gaze of the man standing third from the left, who is looking straight out of the picture and directly at the spectator (see Plate 27).

Plate 27. *Captain Cornelis Backer.* Detail from the *Officers and Sergeants of the Civic Guard Company of St Hadrian* (Plate 26).

Plate 28. *Jean de la Chambre.* Panel, 20·6 × 16.8 cm. Inscribed upper left: 1638/*aet* 33. Unsigned. Slive No. 122. London, National Gallery.

The tiny dimensions of this picture are not obvious from a reproduction, so clever was Hals at reducing the scale of his work, while retaining its quality. The sitter, identified from a later engraving, was a Frenchman working in Haarlem as a calligrapher and schoolmaster and Hals has, in fact, shown him pen in hand. Until 1972, when the picture was bequeathed to the National Gallery by the Misses Alexander, it was little known and it has not always been accepted as authentic by the Hals authorities.

Plate 29. *Portrait of an Unknown Woman.* Canvas, 61·4 × 47 cm. Signed in monogram top left: FH. Probably painted in the late 1630s. Slive No. 131. London, National Gallery.

Many people pass by this excellent portrait because they do not find images of overweight Dutch ladies to their taste. It is in fact one of Hals's most subtle pictures, where he concentrates on the intensity of the expression. It is likely that the picture has been cut down, and this may account for the slightly uncomfortable composition.

Plate 30. *Portrait of an Unknown Man.* Canvas, 114·9 × 86 cm. Unsigned. Probably painted about 1643–5. Slive No. 156. Edinburgh, National Gallery of Scotland.

Plate 31. *Portrait of an Unknown Woman.* Canvas, 115·5 × 85·7 cm. Unsigned. Probably painted about 1643–5. Slive No. 157. Edinburgh, National Gallery of Scotland.

These two pictures are relatively rare surviving examples of a pair of portraits, husband and wife, which have remained together. Unfortunately, they have not been identified, and even the history of these two outstanding pictures is unknown much before they were given to the National Gallery of Scotland in 1885. The date which is usually assigned to them, the middle 1640s, shows that already there are signs that Hals had entered his late phase. This is characterized by the increased use of a particularly intense black, and a loss of interest in the elaboration of embroidery and lace. In the portrait of the woman there is a far greater concentration on the *feel* of her transparent collar than there is on its detail. The great expanse of intense black of the man's costume is contrasted with the white patch of his collar, and this is typical of Hals's work of this period. The change is seen quite dramatically in the *Governors of the Hospital of St Elisabeth at Haarlem* (Haarlem, Frans Hals Museum; Slive No. 140), where the contrast with the last militia group portrait, painted in 1639 (Haarlem, Frans Hals Museum; Slive No. 124), could not be greater. Hals now abandons for ever his bright flags, sashes, beer glasses, and tables loaded with food. Instead, much of his work has an austere dignity, both of mood and colour.

Plate 32. *Family Group with a Negro Servant in a Landscape.* Canvas, 202 × 205 cm. Unsigned. Probably painted about 1648. Slive No. 177. Lugano-Castagnola, Thyssen Collection.

Like the very similar group in the National Gallery, London (Plate 33), this picture has recently been doubted as authentic. This would appear to be unfair, as both are quite consistent with Hals's style of the 1640s. The handling of the collars is very similar to that in the Edinburgh *Portrait of an Unknown Woman* (Plate 31). Slive has pointed out that the landscape on the right was probably painted by Pieter de Molyn, as it is so close in style to the latter's broad dunescapes. The family has not been identified, but it is likely that it belonged to the successful merchant classes, rich enough to afford the luxury of a negro servant.

Plate 33. *Family Group in a Landscape.* Canvas, 148·5 × 251 cm. Unsigned. Probably painted about 1648. Slive No. 176. London, National Gallery.

In many respects this picture is similar to the one in the Thyssen collection (Plate 32), and they must have been painted at approximately the same time. Again the sitters have remained unidentified, and again they appear to be from the successful commercial classes. The two children in the foreground are delightful studies of infantile playfulness, especially the one leaning against the old lady's knees and looking up at the orange which is being proffered.

Plate 34. *Portrait of a Man.* Canvas, 110·5 × 86·3 cm. Signed in monogram lower right: FH. Probably painted about 1650–2. Slive No. 190. New York, Metropolitan Museum of Art.

Hals's ever-increasing solemnity and severity is very obvious in this picture. The sitter appears a kindly man, but his face is composed, and he is not depicted in a lively gesture. Hals has used extraordinarily free brushwork in the treatment of the cuffs and slashed sleeves, and this anticipates the *tour de force* of his last years, the Haarlem *Regents* and *Regentesses* portraits (Plates 42 and 43). As in so many of these late pictures, the sitter has not been identified.

Plate 35. *Isabella Coymans* (detail). Canvas, 116 × 86 cm. Probably painted about 1650–2. Slive No. 189. New York, Rothschild Collection.

The pendant to this dazzling portrait, that of the sitter's husband Stephanus Geraerdts, is

in the Musée Royal des Beaux-Arts in Antwerp. The woman's outward-looking gesture is explained by the fact that the two pictures were meant to be seen together, and they complement one another in mood and handling as well as in composition. The sitters have been identified by the coats of arms painted on each picture. The treatment of the accessories is unusually elaborate for a picture of this period, and is perhaps explained by the high rank of the sitters.

Plate 36. Detail from the *Regents of the Old Men's Almshouse, Haarlem* (Plate 42).

Plate 37. Detail from *Portrait of a Man* (Plate 34).

Plate 38. *Portrait of a Seated Woman.* Panel, 45·5 × 36 cm. Signed in monogram lower right: FH. Probably painted in the 1660s. Slive No. 211. Oxford, Christ Church (Senior Common Room).

Hals continued to paint in this free style for the last ten years of his life, and pictures which fall into this category are very difficult to date precisely. In this small portrait the handling is extremely free, and yet the sitter has all the formal dignity found in the last two large group portraits. A particularly charming touch is the tiny patch of red (ribbon ?) attached to the woman's bracelet. Velazquez had used a similar device of a small area of red on a portrait predominantly cool in colouring in his *Lady with the Fan* (London, Wallace Collection.

Plate 39. Detail from the *Regentesses of the Old Men's Almshouse, Haarlem* (Plate 43).

Plate 40. *Portrait of a Woman* (detail). Canvas, 60 × 55·6 cm. Unsigned. Probably painted in the late 1650s. Slive No. 196. Hull, Ferens Art Gallery.

In common with several of Hals's pictures which have emerged from obscurity in recent years, this painting has not been without its detractors. Slive rightly regards it as one of the artist's most moving pictures of the 1650s. The woman's gentle character shines through, and she has an air of quiet reassurance. The sitter has, however, remained unidentified.

Plate 41. Detail from *Portrait of a Seated Woman* (Plate 38).

Plate 42. *Regents of the Old Men's Almshouse, Haarlem.* Canvas, 176·5 × 256 cm. Unsigned. Probably painted about 1663–5. Slive No. 221. Haarlem, Frans Hals Museum.

There is no real indication among Hals's last small portraits that he was about to paint this and the picture following. If neither picture had survived it would not be possible to suspect their existence. Much ink has been spilled already praising their qualities; nineteenth-century critics, however, thought that the very freedom of the brushwork (see Plate 45) was in fact a defect. Suffice it to say that most people who have been privileged to stand in front of these pictures, which hang in a relatively small room, come away with the very definite impression that they have been in front of two of the greatest groups of portraits ever painted.

Plate 43. *Regentesses of the Old Men's Almshouse, Haarlem.* Canvas, 170·5 × 249·5 cm. Unsigned. Probably painted about 1663–5. Slive No. 222. Haarlem, Frans Hals Museum.

Of the two 'Regents' pictures, this one has perhaps excited more critical attention. There is greater evidence of human frailty in Hals's treatment of these gloomy old women, responsible for the administration and dispensation of public charity. The brushwork in many parts of the picture is the freest that Hals ever used. But the composition as a whole appears dignified and formal. This is the effect of Hals's close observation of the brittle and rigid bones of the very old, who had lost their suppleness of both body and mind.

Plate 44. Detail from *Boy with a Skull* (Plate 8).

Plate 45. Detail from the *Regents of the Old Men's Almshouse, Haarlem* (Plate 42), to show brushwork.

Plate 46. Detail from the *Regents of the Old Men's Almshouse, Haarlem* (Plate 42).

Plate 47. Detail from the *Regentesses of the Old Men's Almshouse, Haarlem* (Plate 43).

Plate 48. *Portrait of a Man in a Slouch Hat.* Canvas, 79·5 × 66·5 cm. Signed in monogram on the left near the shoulder: FH. Probably painted after 1660. Slive No.217. Kassel, Hessisches Landesmuseum.

The composition of this picture is curiously similar to the portrait of *Isaac Abrahamz. Massa* (Plate 14), painted almost forty years before. In every other respect the difference could not be greater. The handling of the paint has become free to the point where the picture has almost become a sketch. The accessories – the chair, the enormous hat – appear almost flimsy. But even in extreme old age, and he must have been around eighty when he painted this picture, Hals never lost his ability to observe the humour and self-confidence of a middle-aged man.

Outline Biography

c. 1580 Probably born at Antwerp, although this is disputed. The alternative place is Malines, a little to the south.

1591 By this date the Hals family must have arrived in Haarlem, as the birth of Hals's younger brother, Dirck, is recorded there.

before 1603 Probably a pupil of Carel van Mander, who appears to have had very little influence on his work.

1610 Recorded as a member of the painters' Guild of St Luke at Haarlem.

1616 Painted his first large group portrait, the *Banquet of the Officers of the Civic Guard Company of St George* (Plate 1).

1627 Painted the *Banquet of the Officers of the Civic Guard Company of St George* (Plate 11) and the *Banquet of the Officers of the Civic Guard Company of St Hadrian* (Plate 12).

1633 Painted the *Officers and Sergeants of the Civic Guard Company of St Hadrian* (Plate 26) and, exceptionally, painted a militia group portrait for Amsterdam, which he left unfinished, and which was completed in 1637 by Pieter Codde.

1639 Painted the *Officers and Sergeants of the Civic Guard Company of St George at Haarlem* (Haarlem, Frans Hals Museum).

1641 Painted the group portrait of the *Governors of St Elisabeth's Hospital at Haarlem* (Haarlem, Frans Hals Museum).

1644 Recorded as an officer of the Haarlem Guild of painters.

1662 The city authorities of Haarlem started to pay small sums towards Hals's upkeep, because he was destitute.

c. 1663–5 Painted the two celebrated group portraits of the *Regents* (Plate 42) and *Regentesses of the Old Men's Almshouse, Haarlem* (Plate 43).

1666 Death of the artist at Haarlem.

Bibliography

One of the best appreciations of Hals in the nineteenth century is by Eugène Fromentin in *Les Maîtres d'autrefois*, 1876 (Phaidon edition, 1948, pp. 166–74), although he disliked the late group portraits.

In the early twentieth century there were several attempts to define Hals's work by the compilation of *catalogues raisonnés*. The earliest was Cornelis Hofstede de Groot's *Catalogue Raisonné of the works of the most eminent Dutch Painters*, Vol. III, 1910. This was followed by Bode's great Corpus: Wilhelm von Bode and M. J. Binder: *Frans Hals, sein Leben und seine Werke*, Berlin, 1914. The effect of this was that too many pictures began to be attributed to Hals, reaching a peak in the second edition of Valentiner's *Klassiker der Kunst, Frans Hals*, 1923. The reaction to Bode and Valentiner came with N. S. Trivas (*The Paintings of Frans Hals*, Phaidon, 1941), who omitted a large number of perfectly genuine pictures.

Modern scholarship began with the catalogue of the Frans Hals Exhibition held in Haarlem in 1962, which was compiled by Seymour Slive. Slive's three-volume monograph, *Frans Hals* (Phaidon, 1970–4), records all that is at present known, gives a penetrating stylistic analysis and establishes a convincing corpus of his work, based on a long familiarity with the pictures themselves.

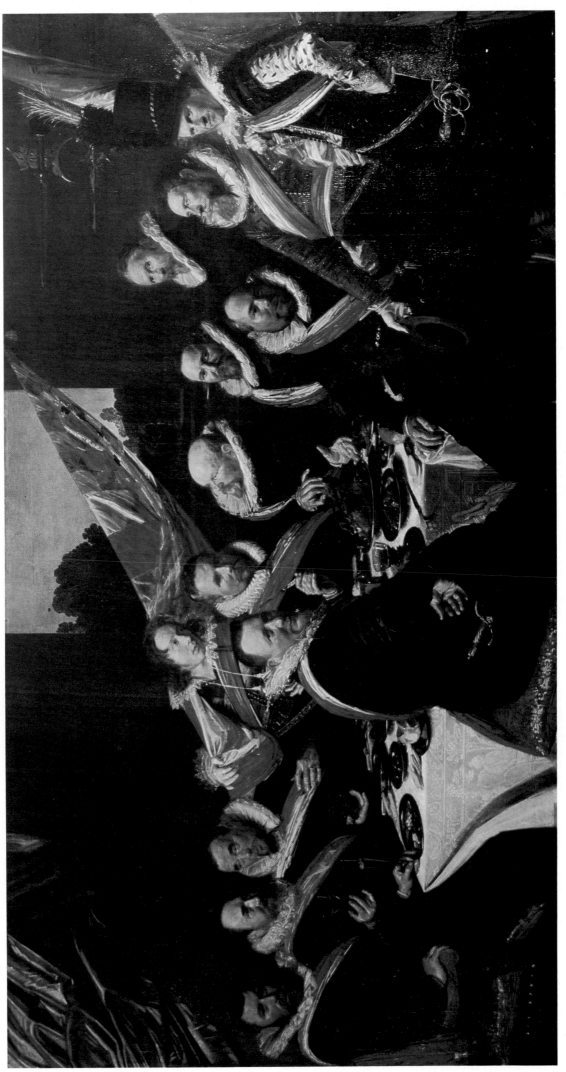

1. *Banquet of the Officers of the Civic Guard Company of St George.* 1616. Haarlem, Frans Hals Museum

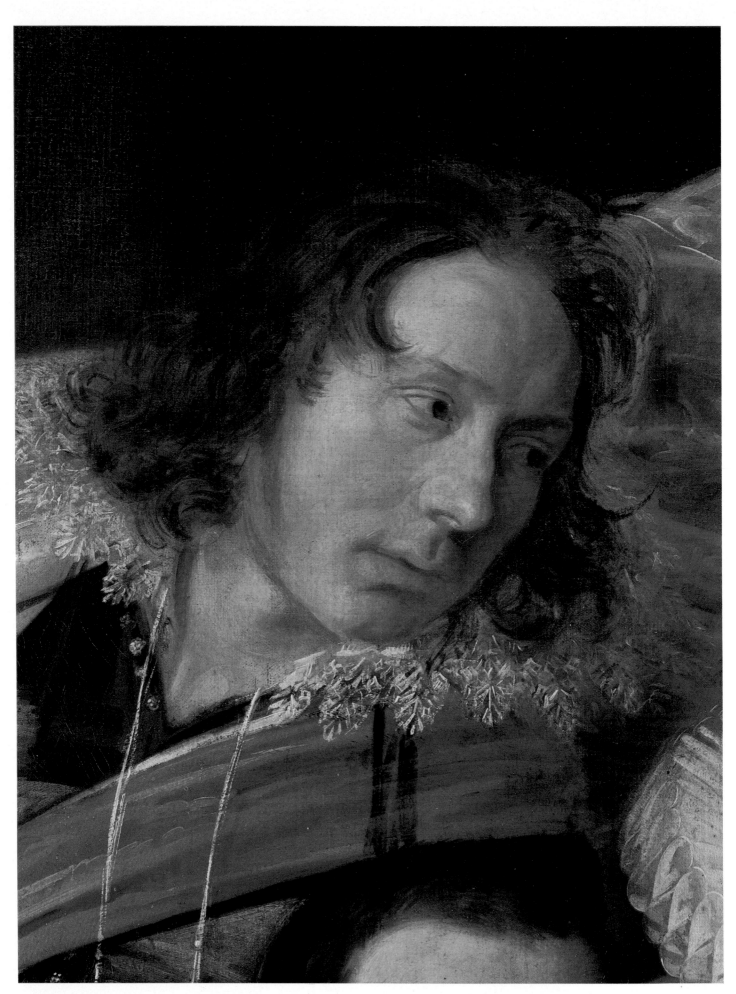

2. Detail from the *Banquet of the Officers of the Civic Guard Company of St George* (Plate 1)

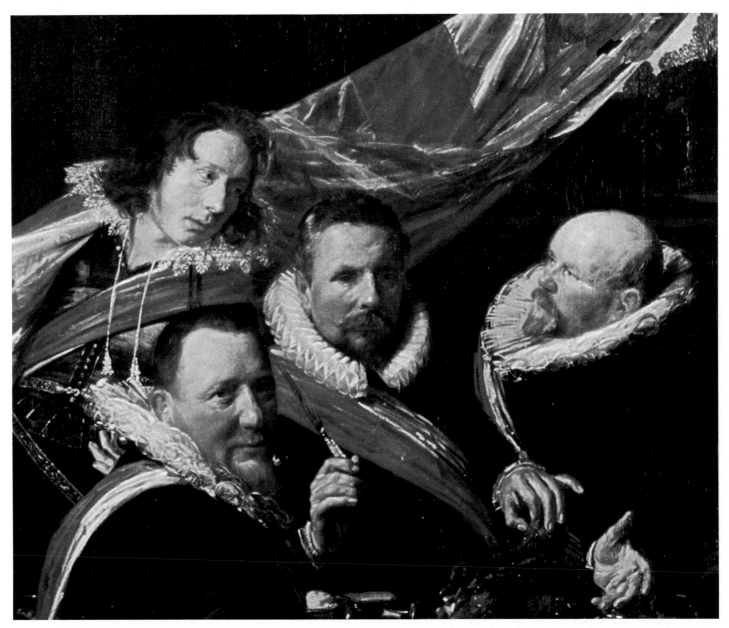

3. Detail from the *Banquet of the Officers of the Civic Guard Company of St George* (Plate 1)

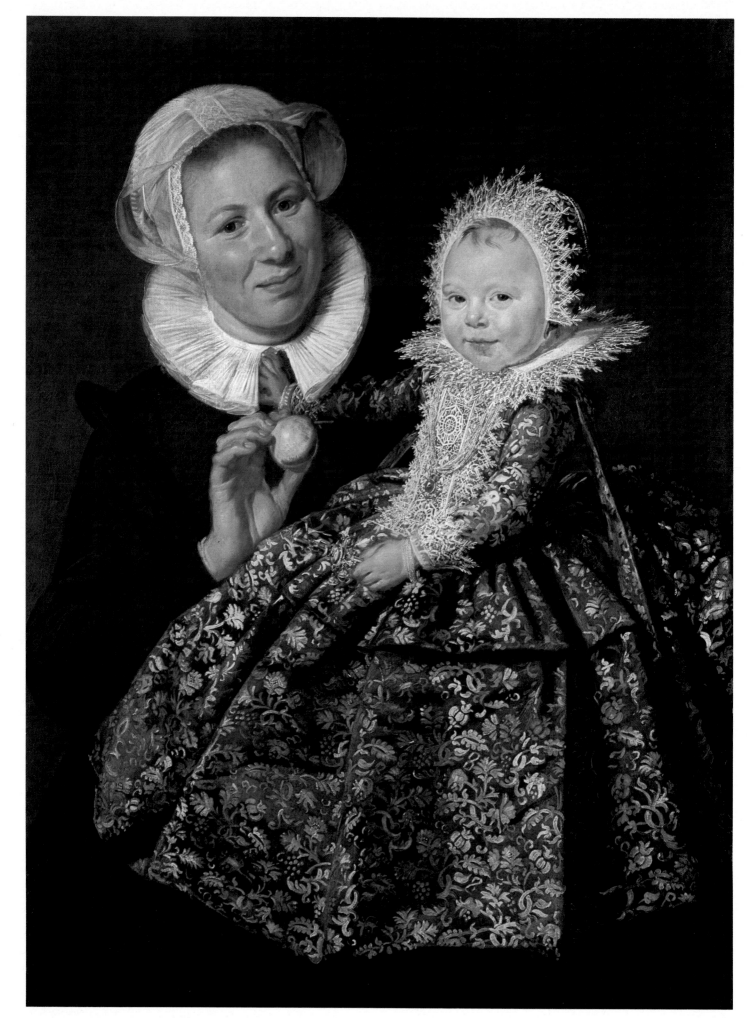

4. *Nurse and Child.* About 1620. Berlin-Dahlem, Staatliche Museen

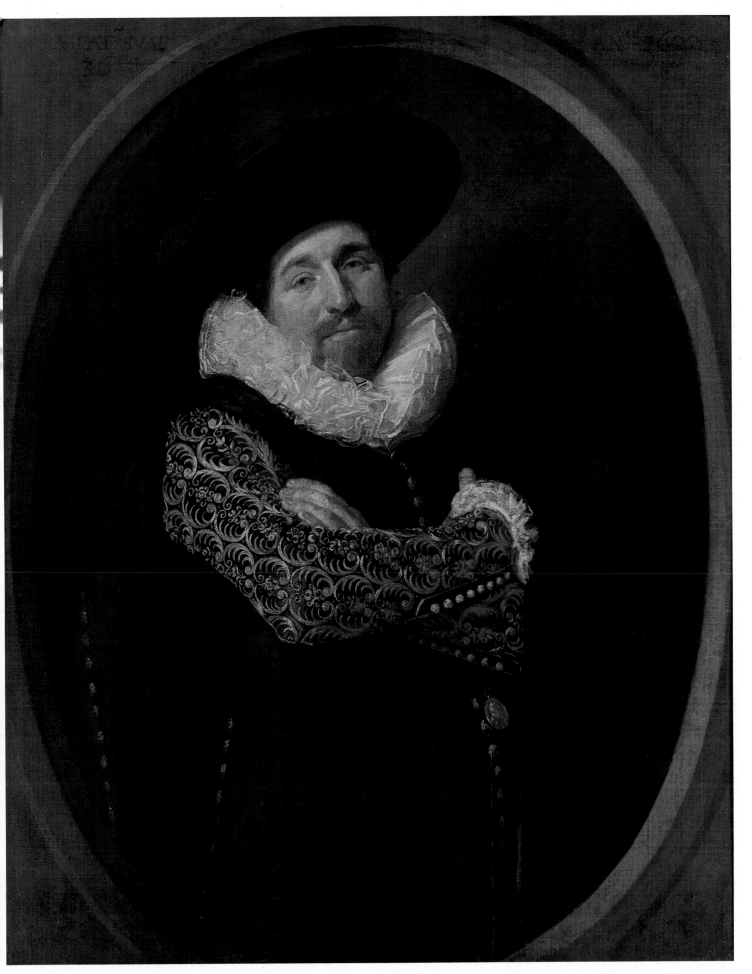

5. *Portrait of a Man with Folded Arms*. 1622. Chatsworth, The Duke of Devonshire and the Trustees of the Chatsworth Settlement

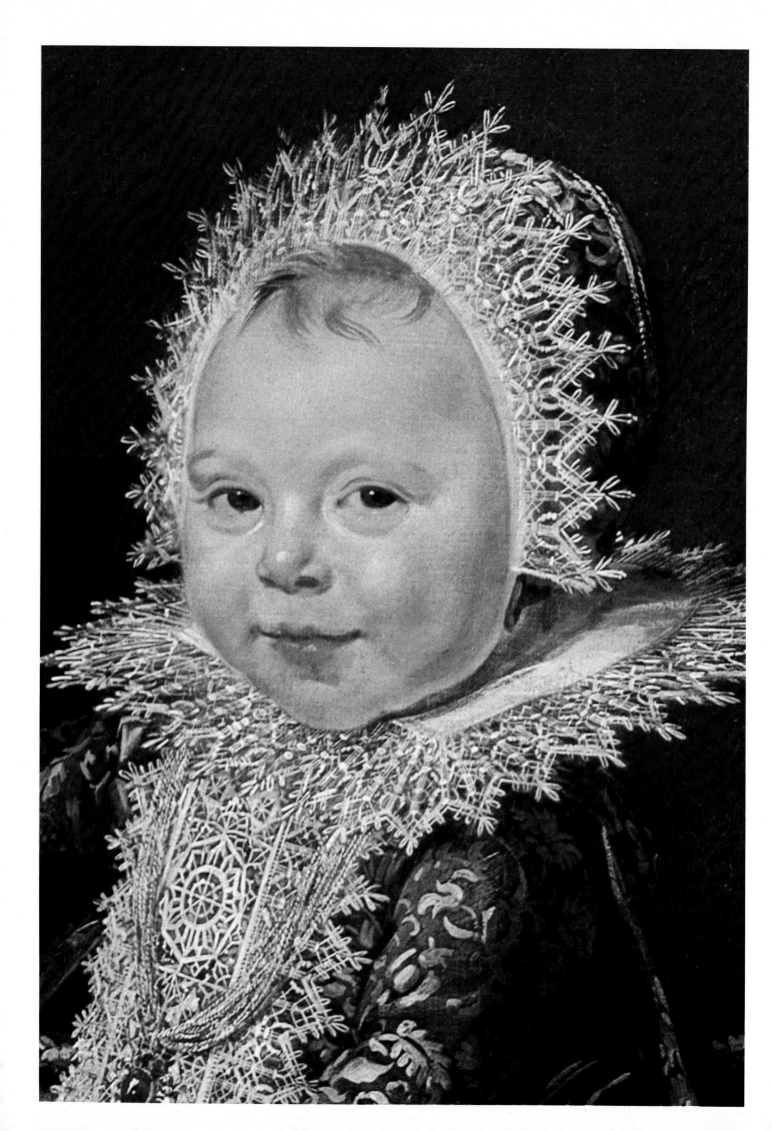

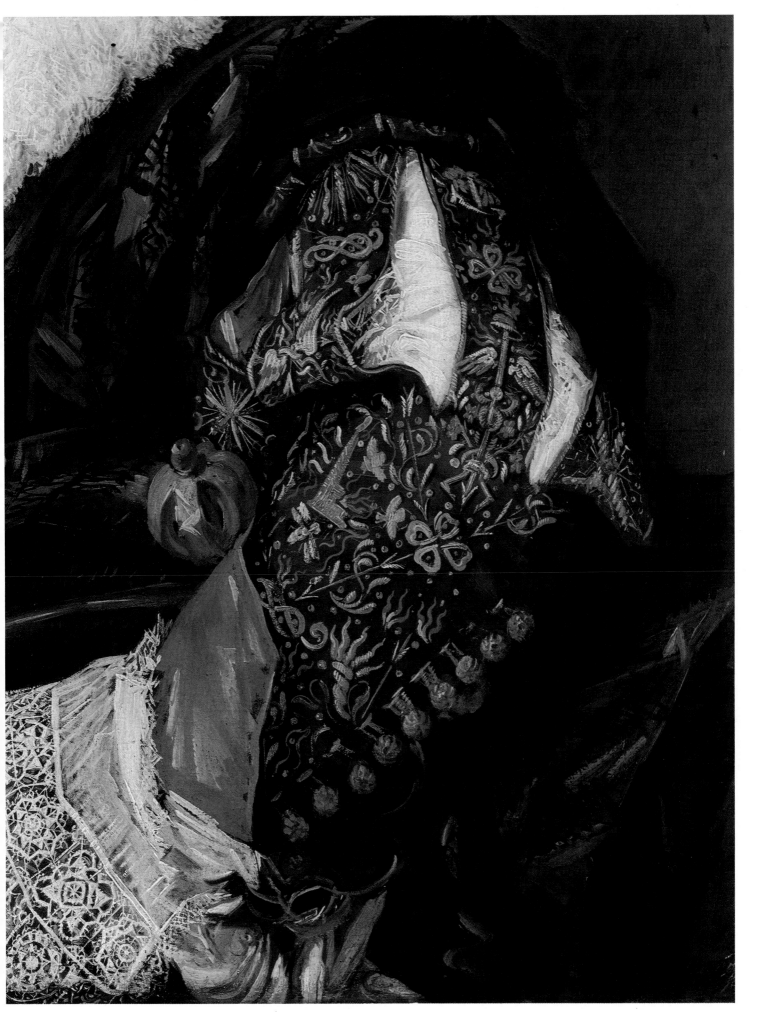

7. Detail from *The Laughing Cavalier* (Plate 9)

Detail from *Nurse and Child* (Plate 4)

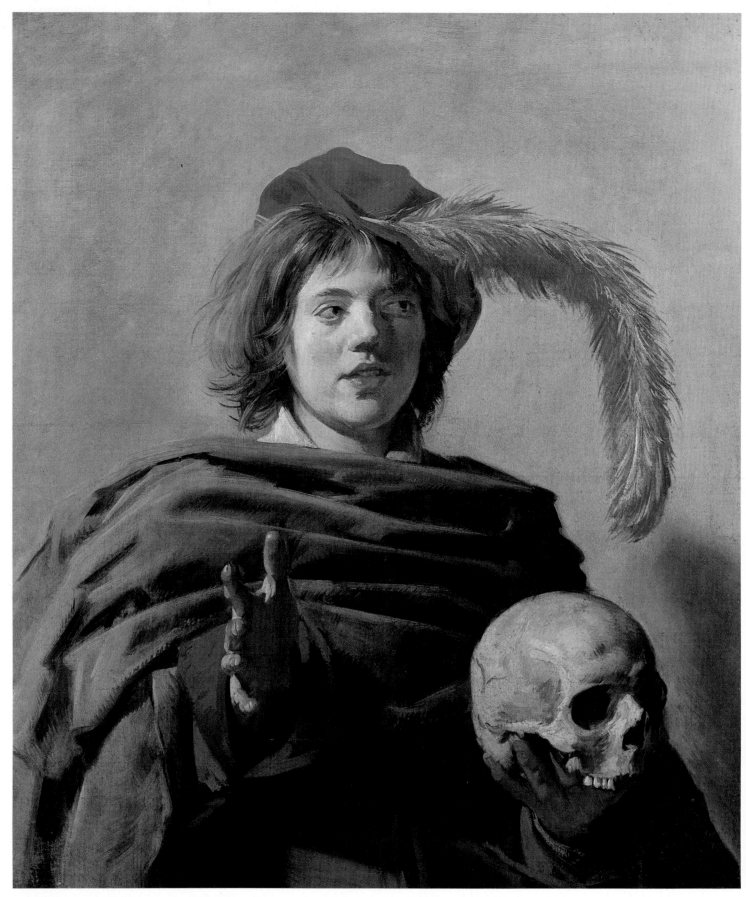

8. *Boy with a Skull*. About 1626–8. Private Collection

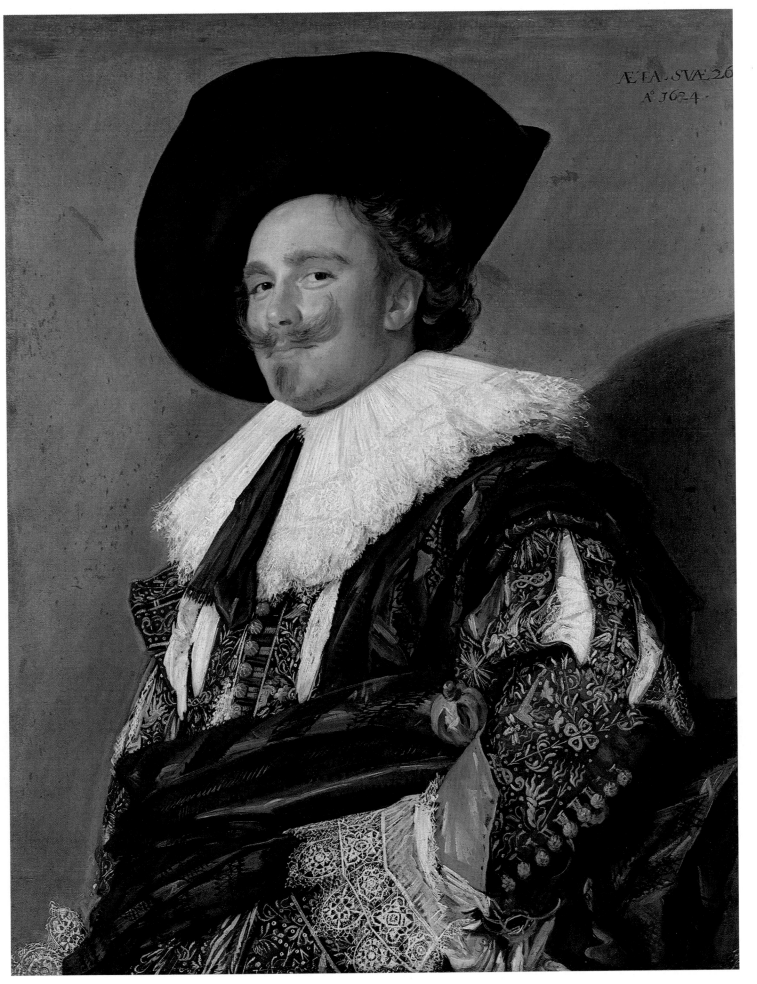

AETA SVAE 26
A° 1624

9. *The Laughing Cavalier.* 1624. London, Wallace Collection

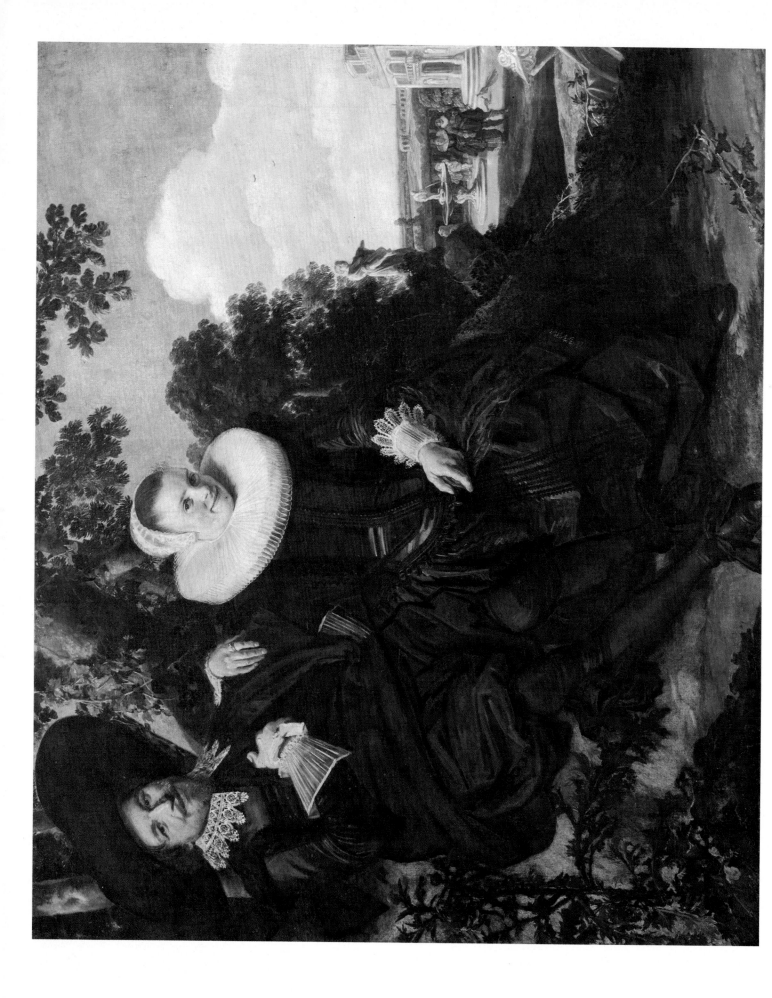

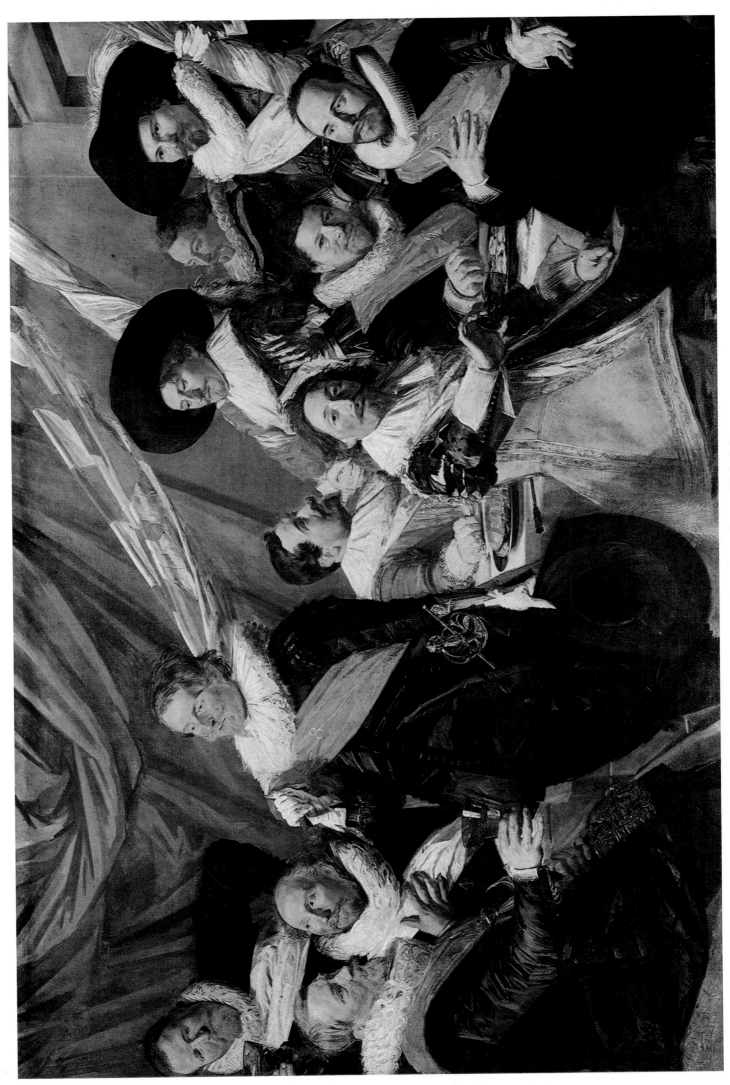

11. *Banquet of the Officers of the Civic Guard Company of St George*. 1627. Haarlem, Frans Hals Museum

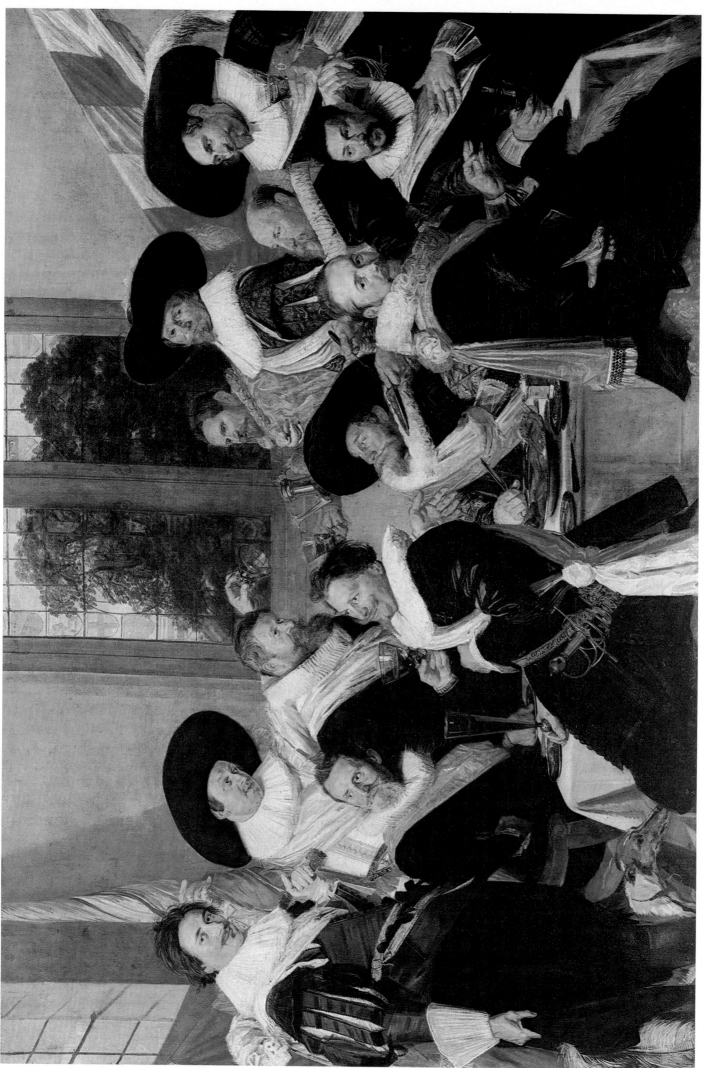

12. *Banquet of the Officers of the Civic Guard Company of St Hadrian*. 1627. Haarlem, Frans Hals Museum

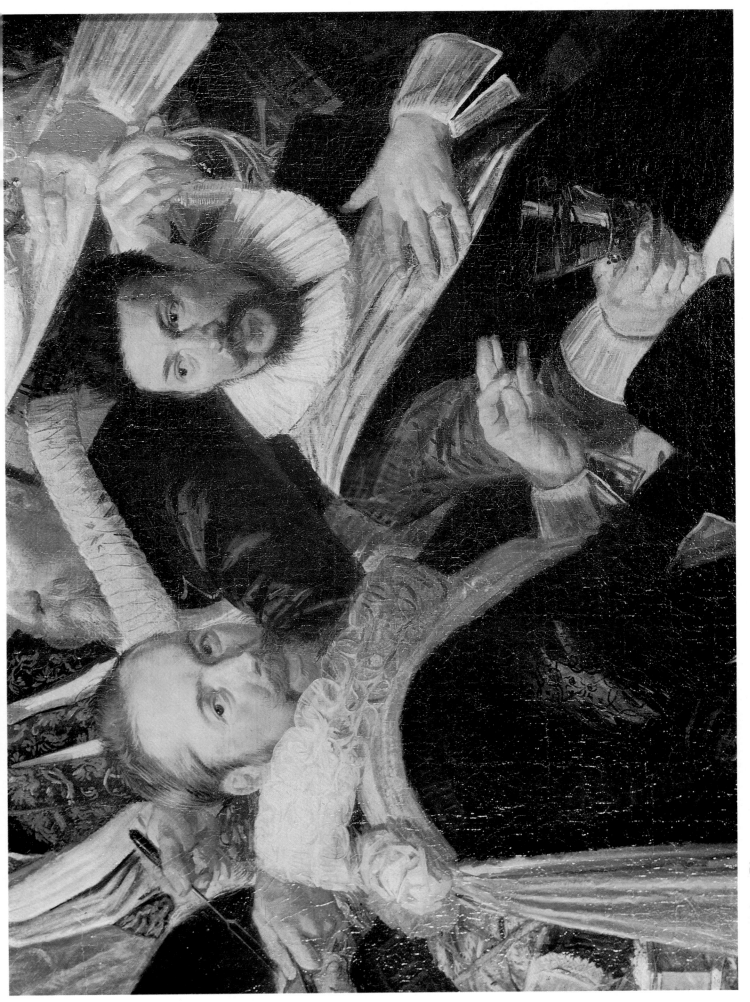

13. Detail from Plate 12

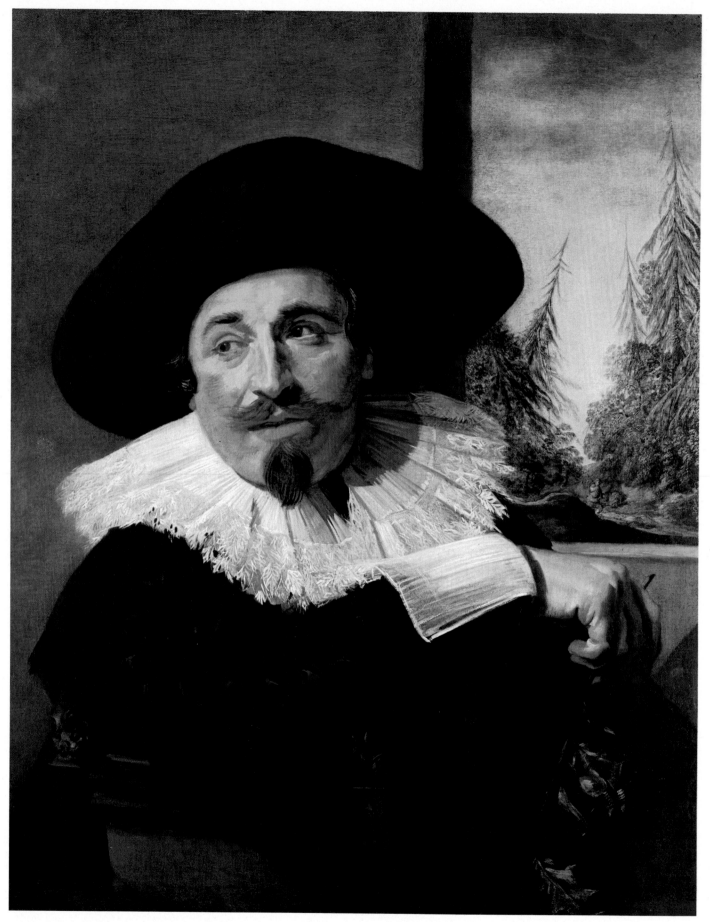

14. *Isaac Abrahamz. Massa.* 1626? Toronto, Art Gallery of Ontario

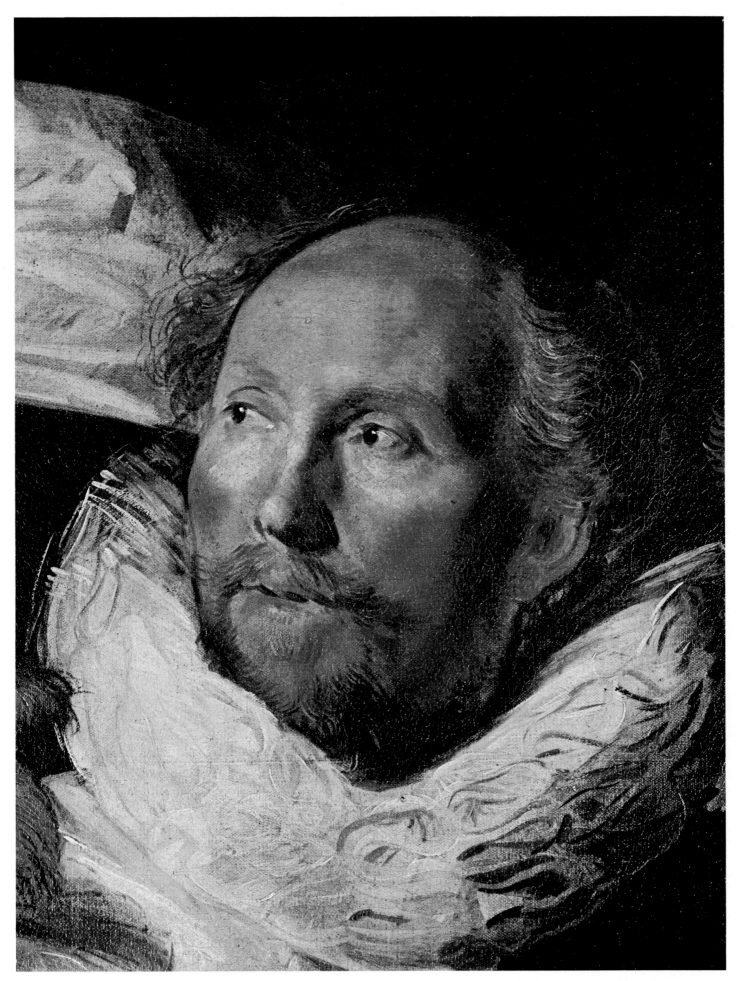

15. Detail from the *Banquet of the Officers of the Civic Guard Company of St George* (Plate 11)

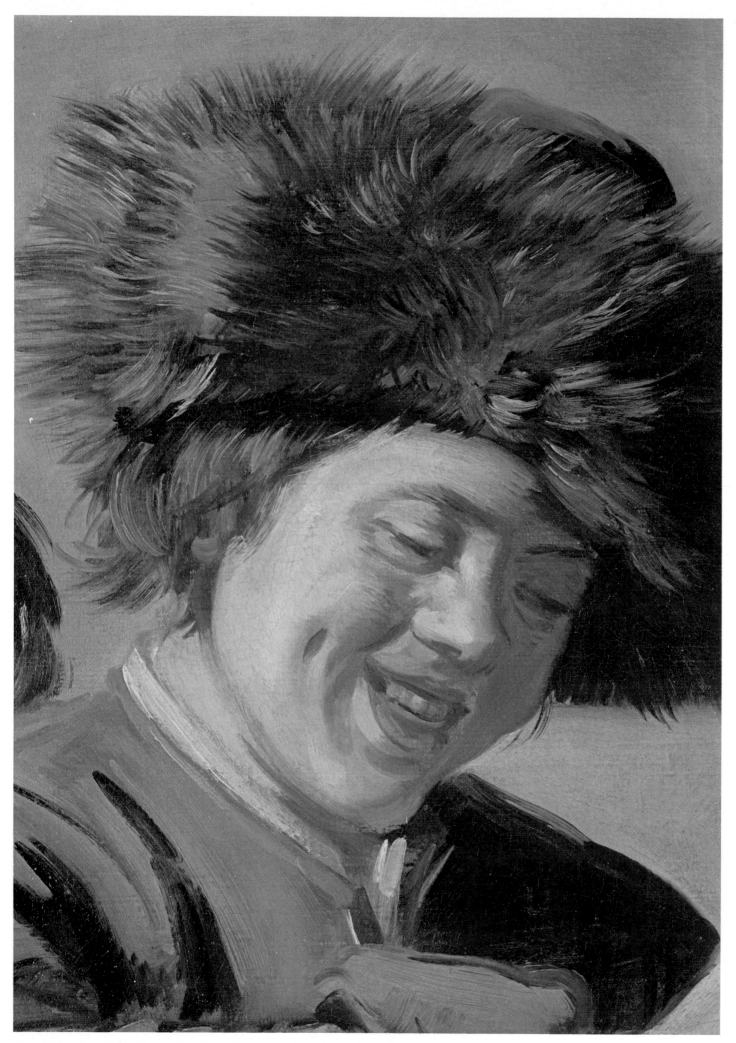

16. *Two Laughing Boys* (detail). About 1626–8. Leerdam, Hofje van Aerden, on loan to Rotterdam, Museum Boymans-van Beuningen

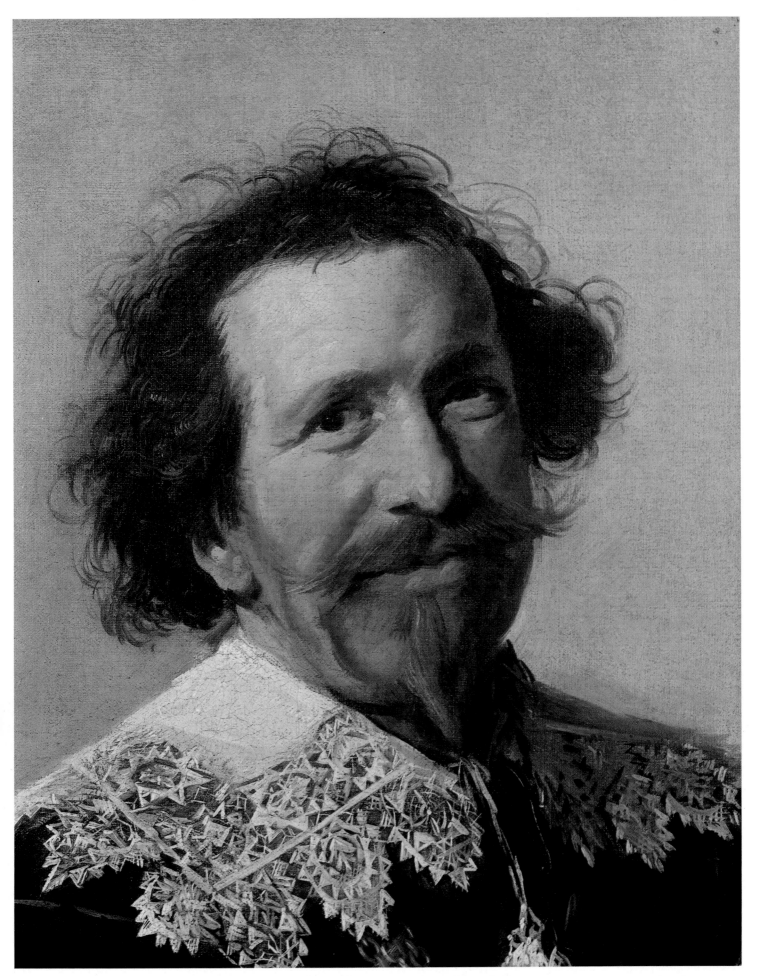

17. *Pieter van den Broecke* (detail). 1633. London, Kenwood House, Iveagh Bequest

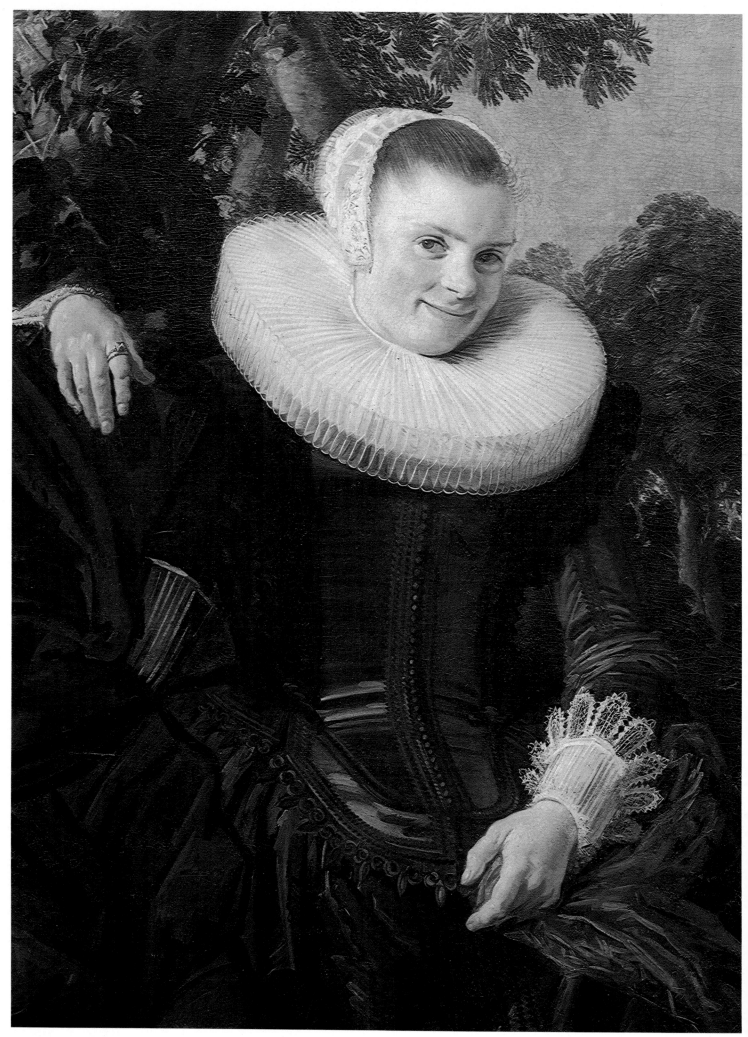

18. Detail from *A Couple in a Garden* (Plate 10)

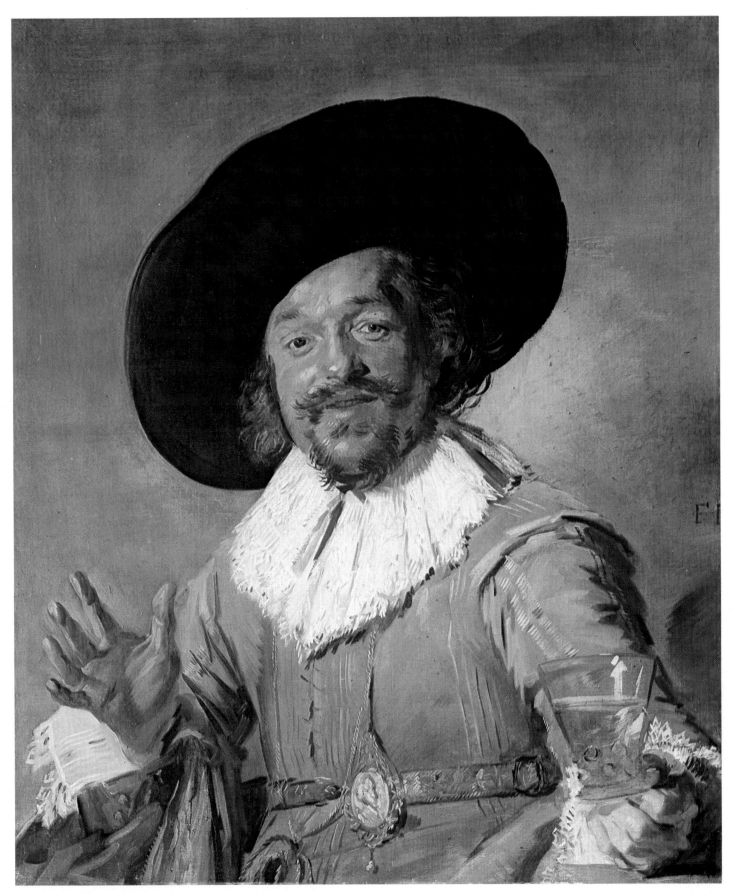

19. *The Merry Drinker*. About 1628–30. Amsterdam, Rijksmuseum

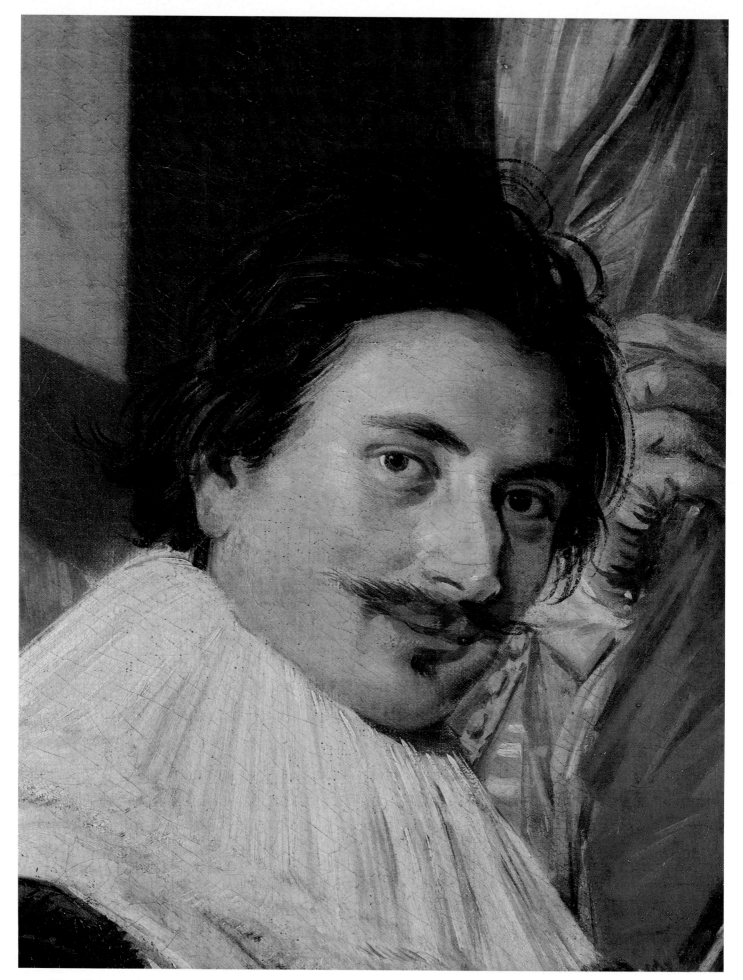

20. Detail from the *Banquet of the Officers of the Civic Guard Company of St Hadrian* (Plate 12)

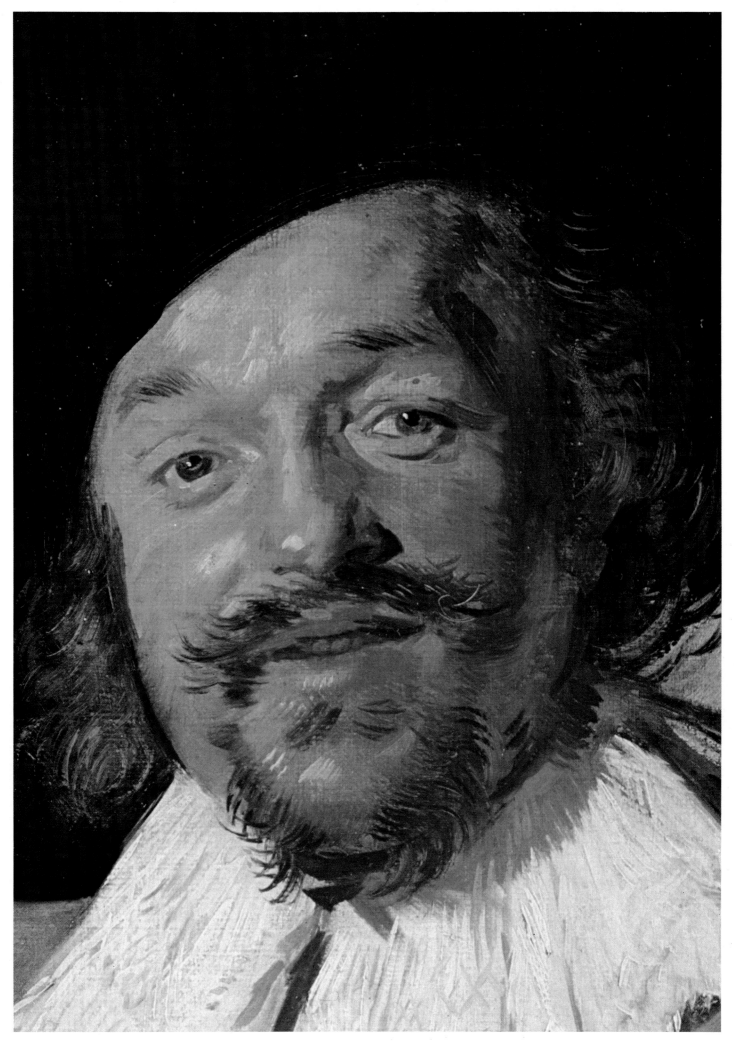

21. Detail from *The Merry Drinker* (Plate 19)

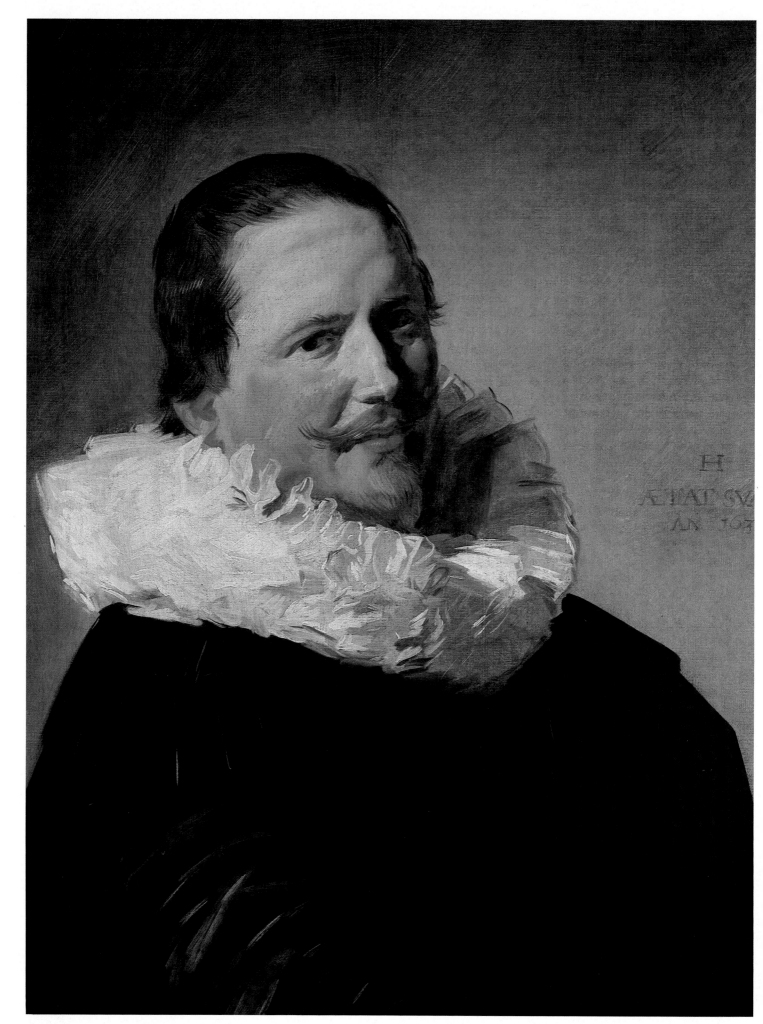

22. *Portrait of a Man in his Thirties.* 1633. London, National Gallery

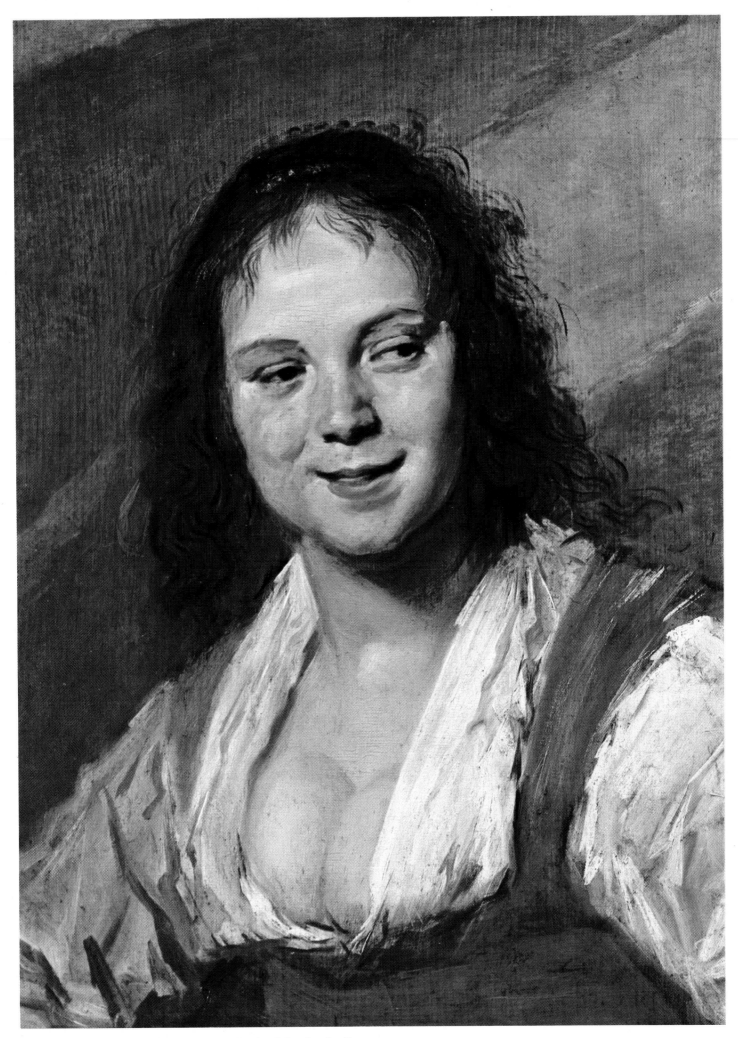

23. *Gipsy Girl*. About 1628–30. Paris, Musée du Louvre

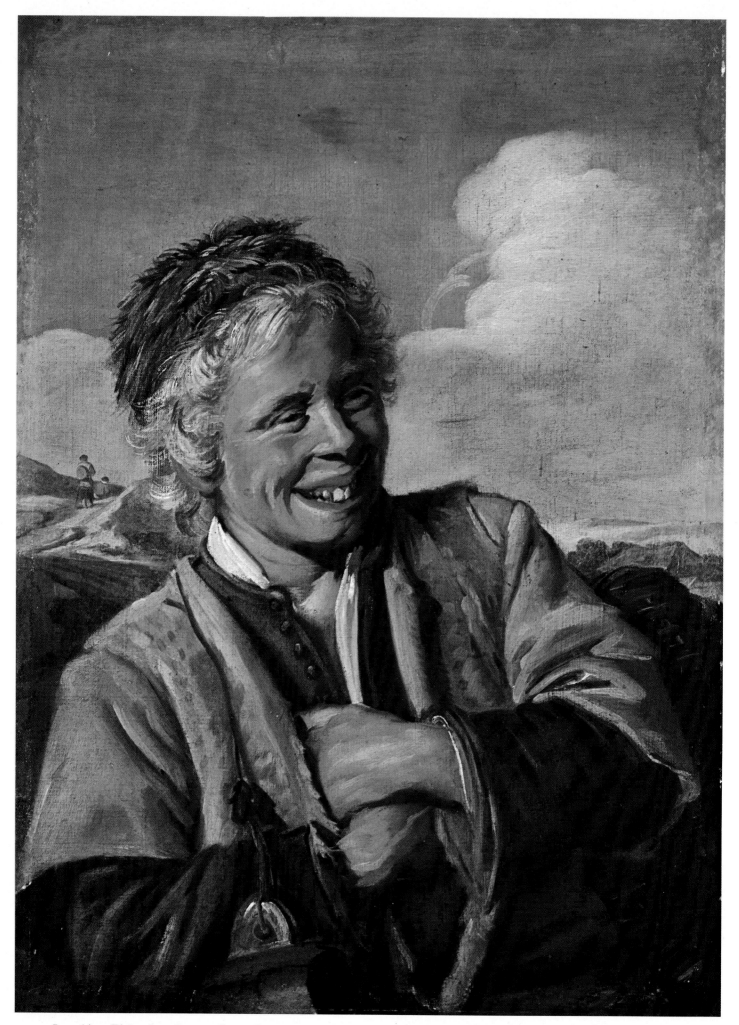

24. *Laughing Fisher-boy*. Late 1620s. Rotterdam, Museum Boymans-van Beuningen

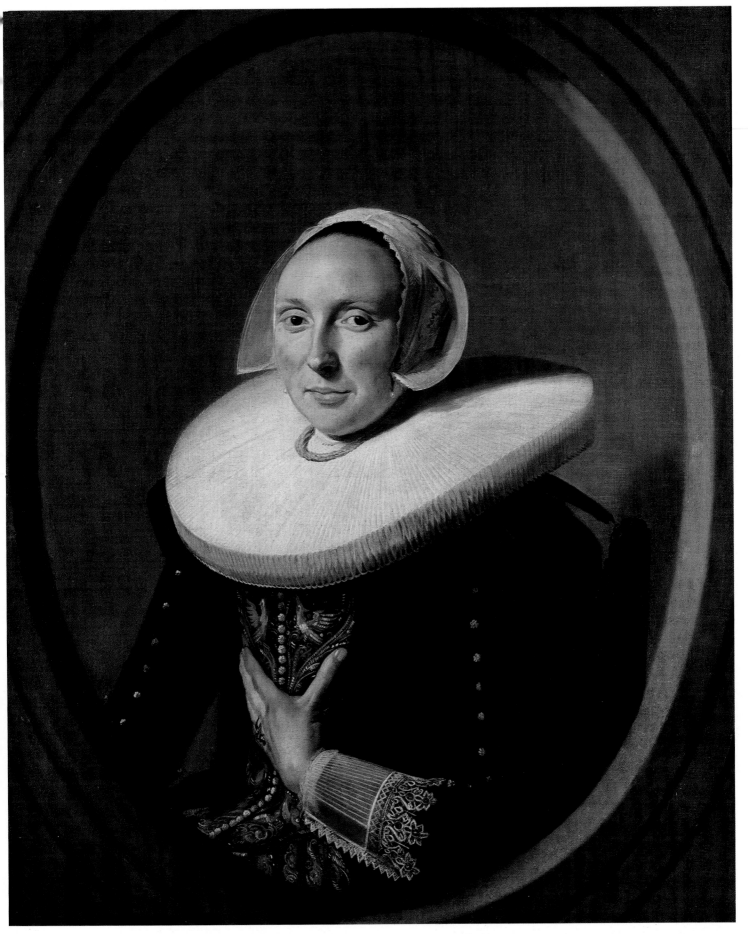

25. *Portrait of an Unknown Woman*. About 1635–8. London, National Gallery

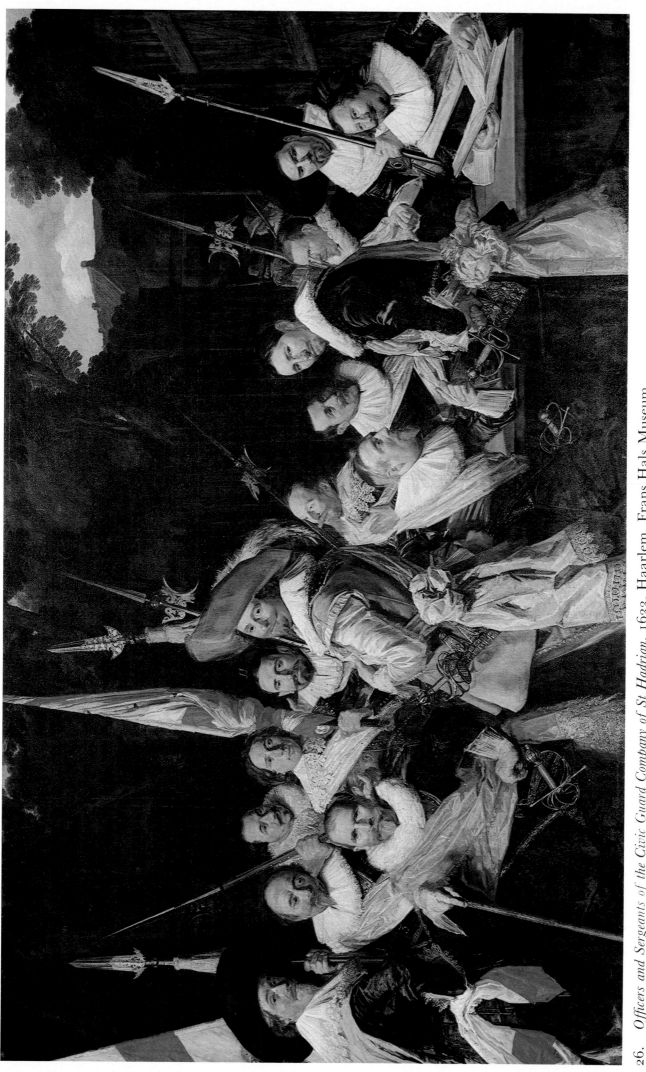

26. *Officers and Sergeants of the Civic Guard Company of St Hadrian.* 1633. Haarlem, Frans Hals Museum

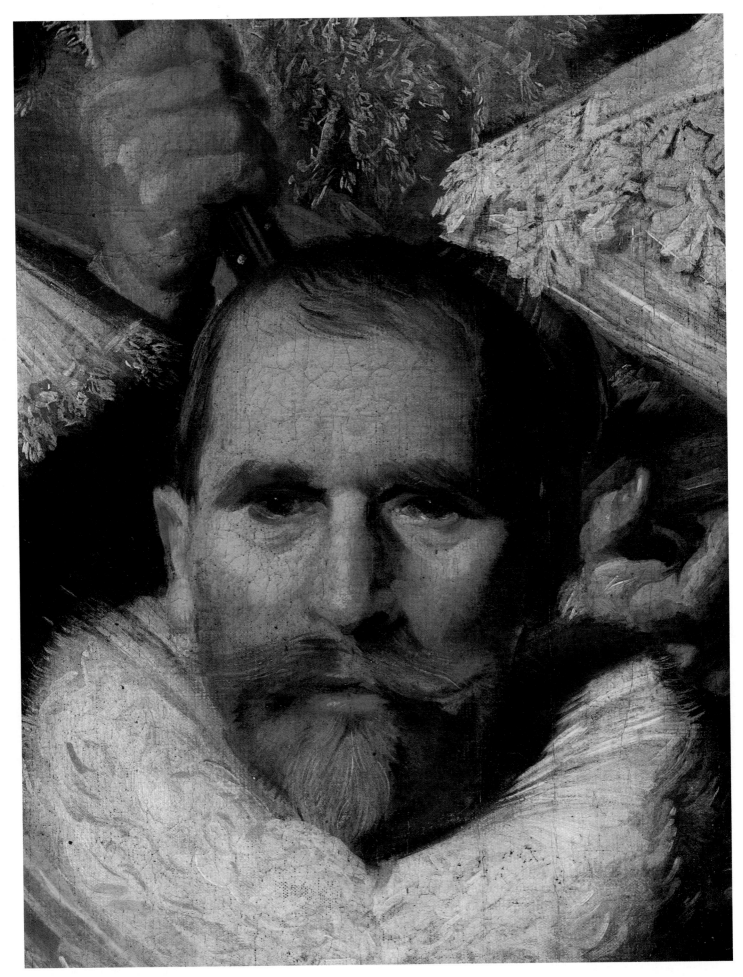

27. Detail from Plate 26

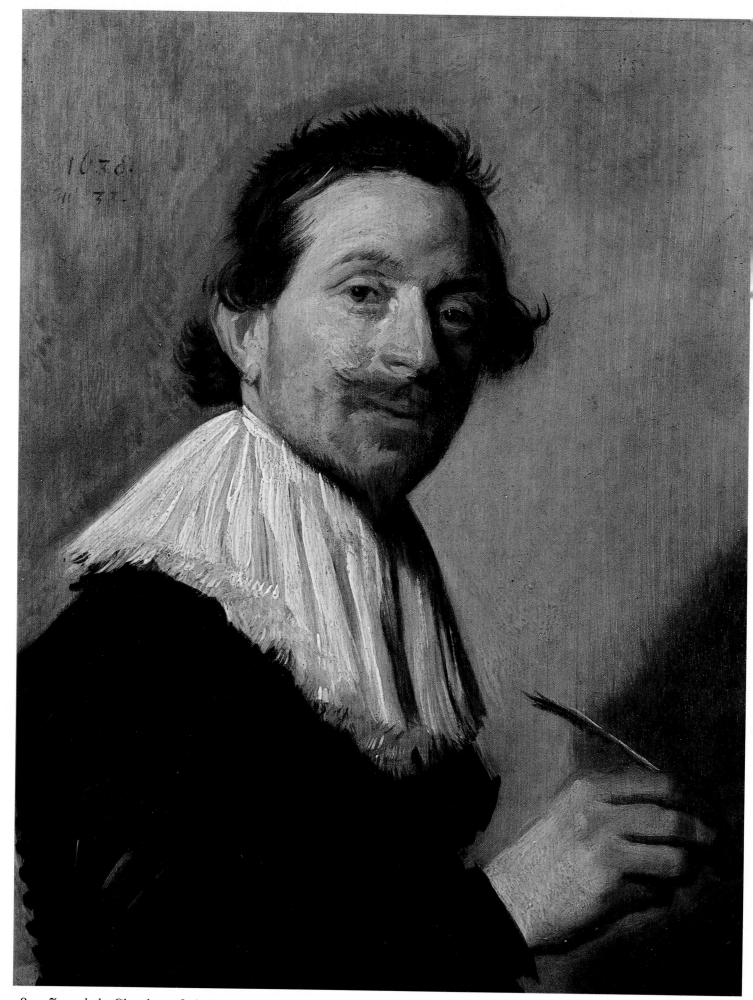

28. *Jean de la Chambre*. 1638. London, National Gallery

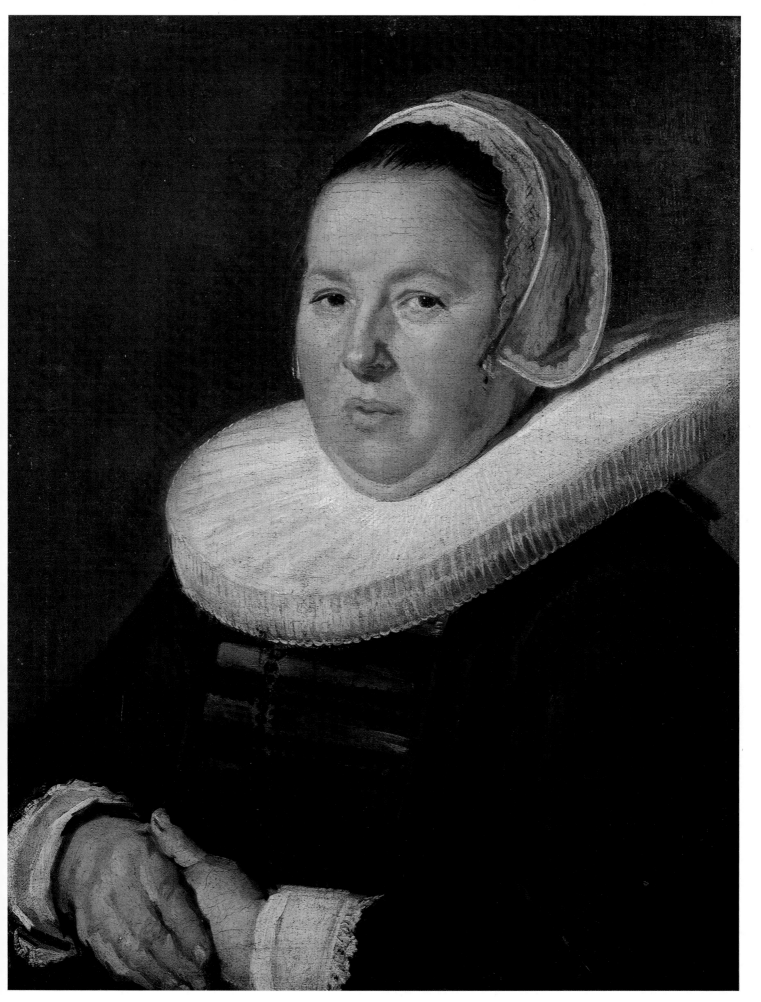

29. *Portrait of an Unknown Woman*. Late 1630s. London, National Gallery

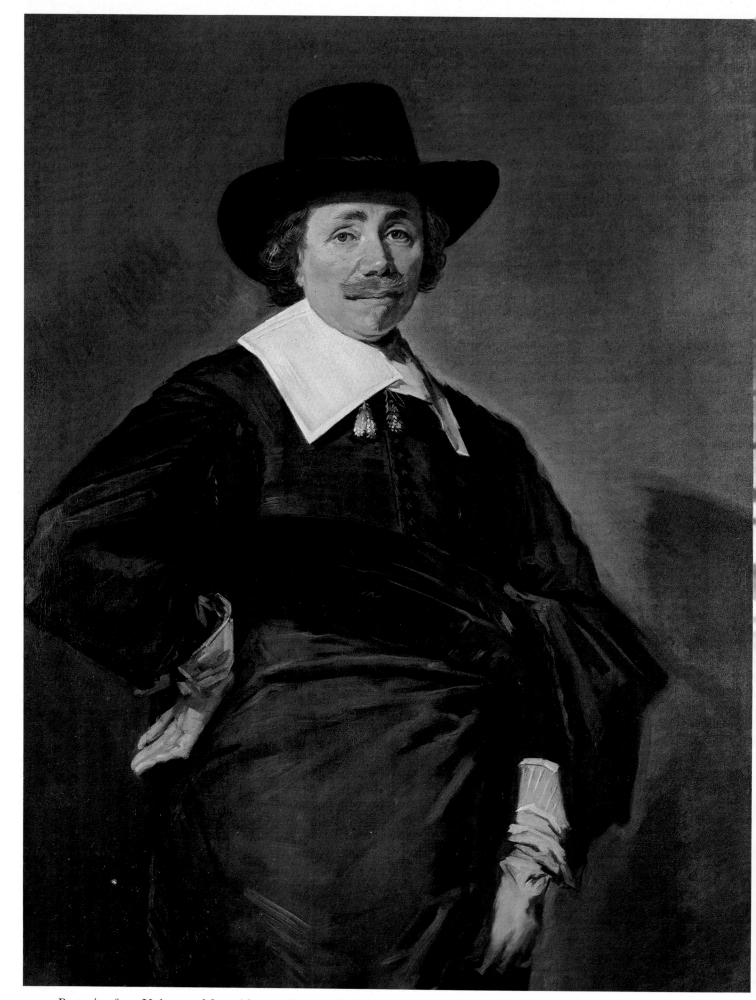

30. *Portrait of an Unknown Man*. About 1643–5. Edinburgh, National Gallery of Scotland

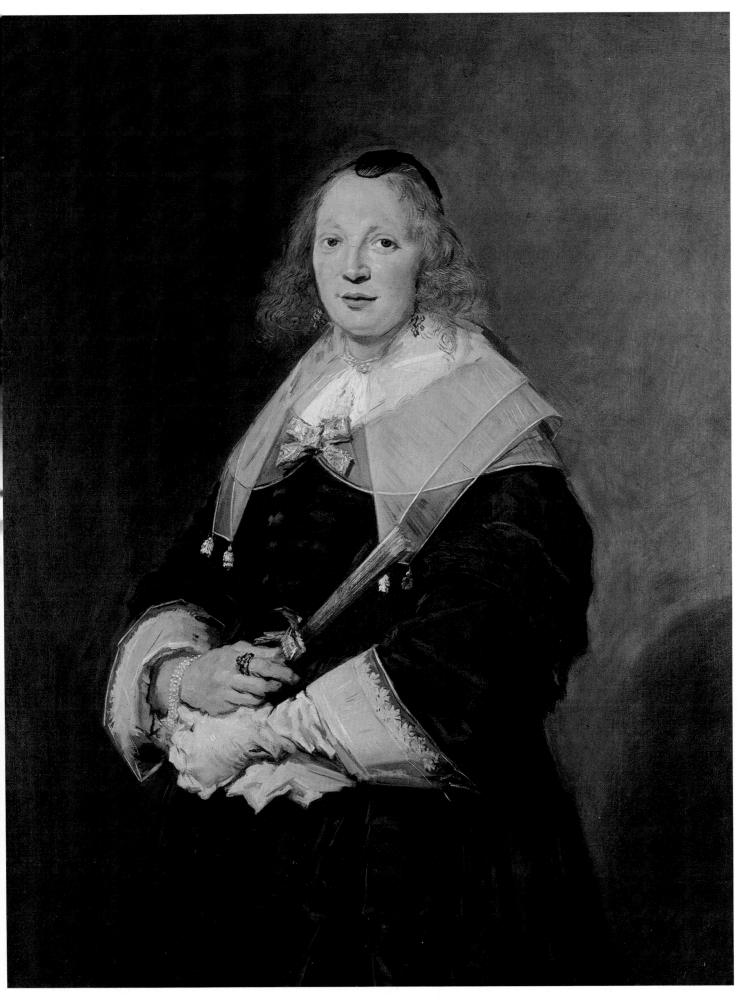

31. *Portrait of an Unknown Woman*. About 1643–5. Edinburgh, National Gallery of Scotland

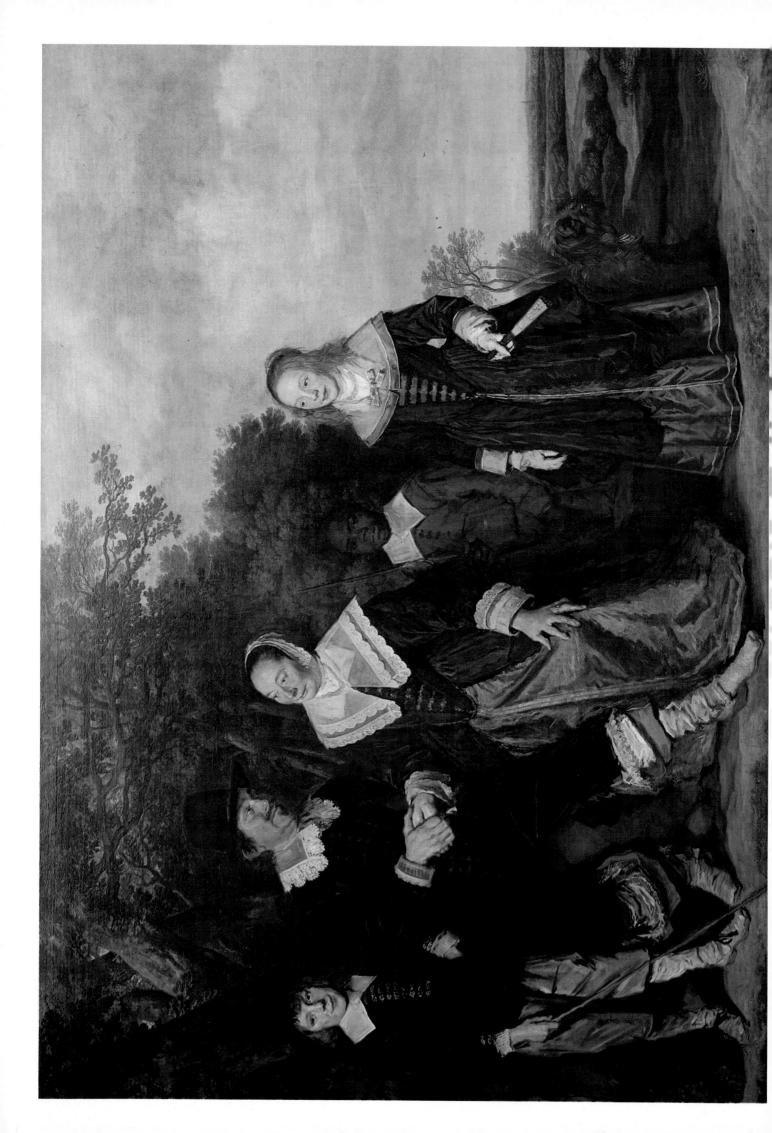

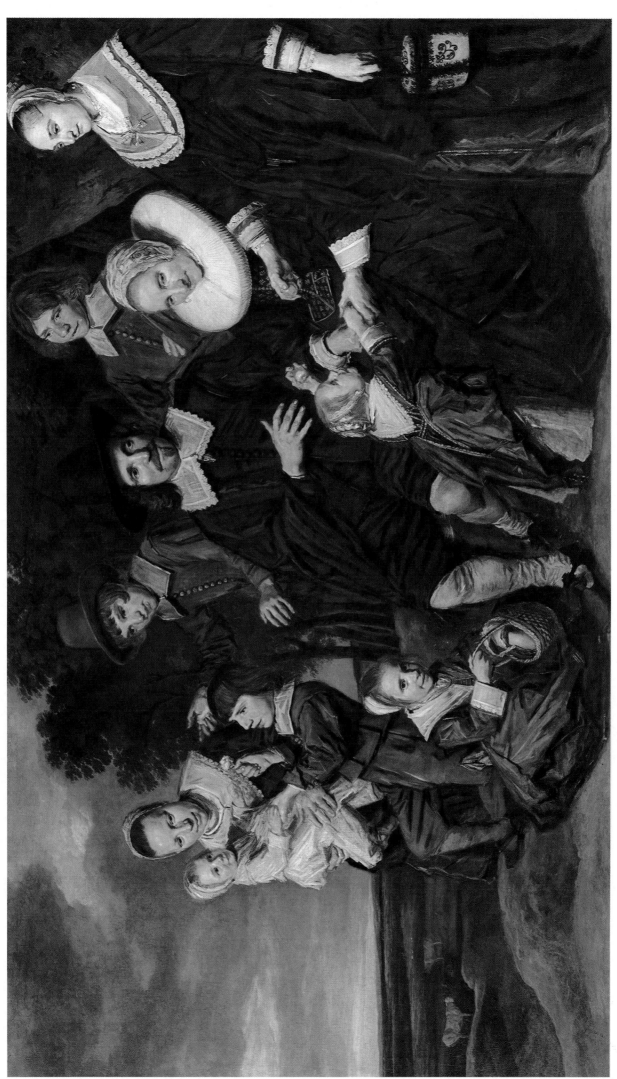

33. *Family Group in a Landscape*. About 1648. London, National Gallery

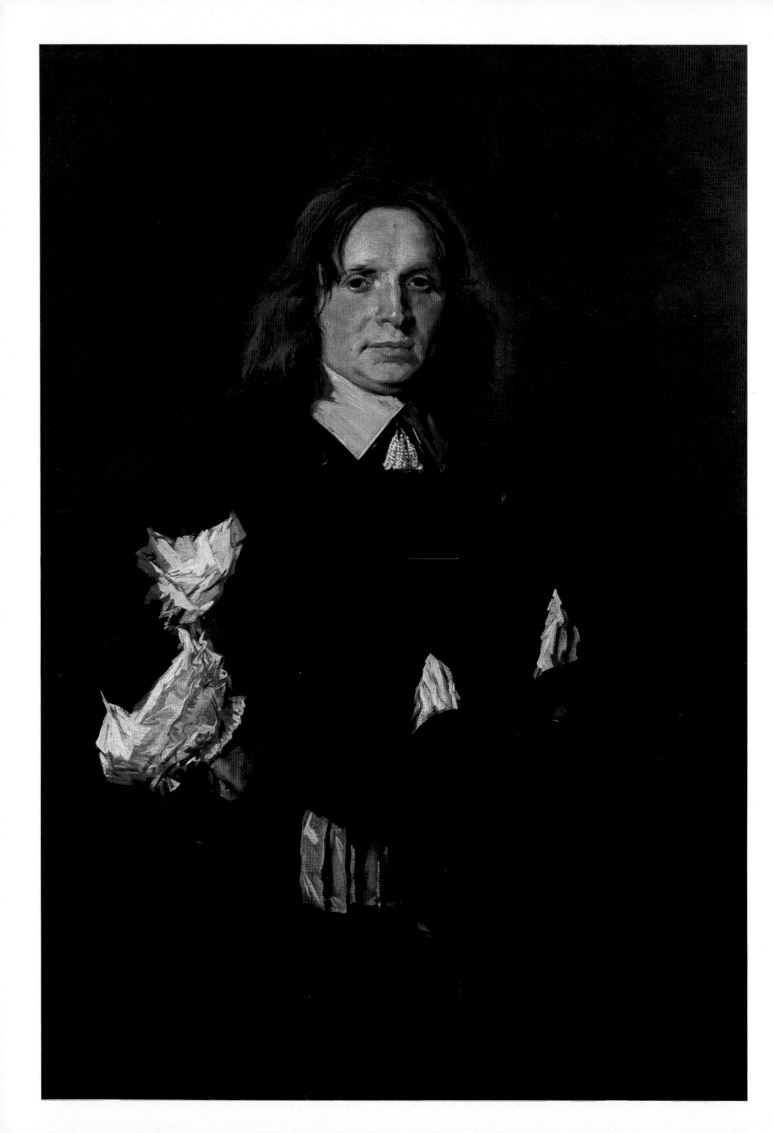

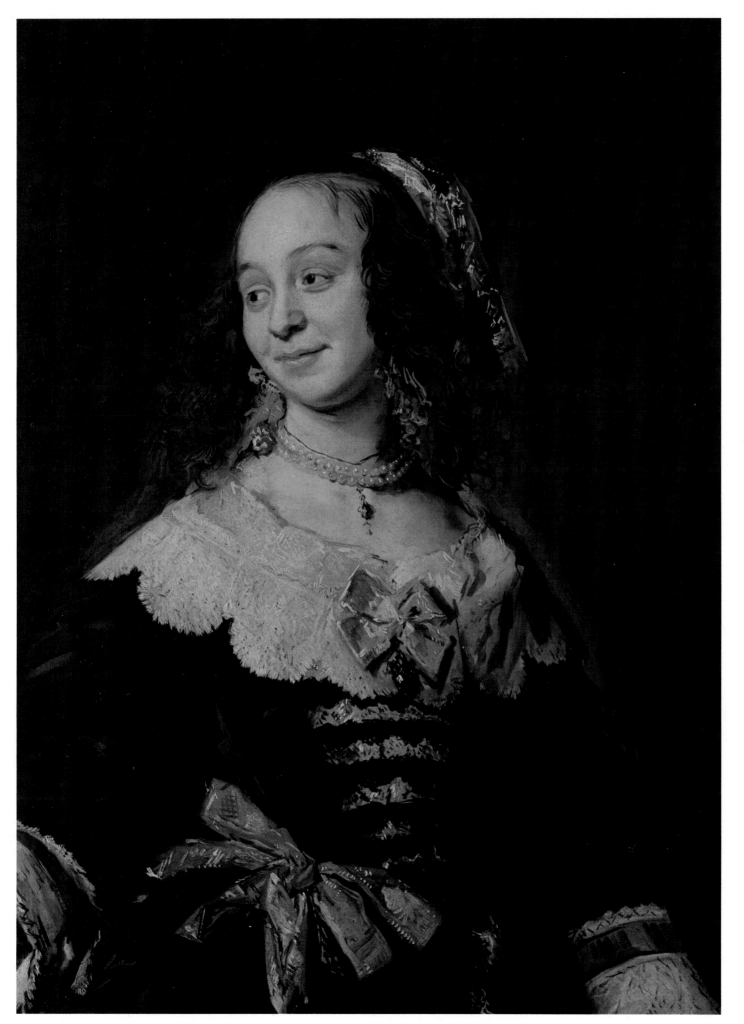

35. *Isabella Coymans* (detail). About 1650–2. New York, Rothschild Collection

Portrait of a Man. About 1650–2. New York, Metropolitan Museum of Art

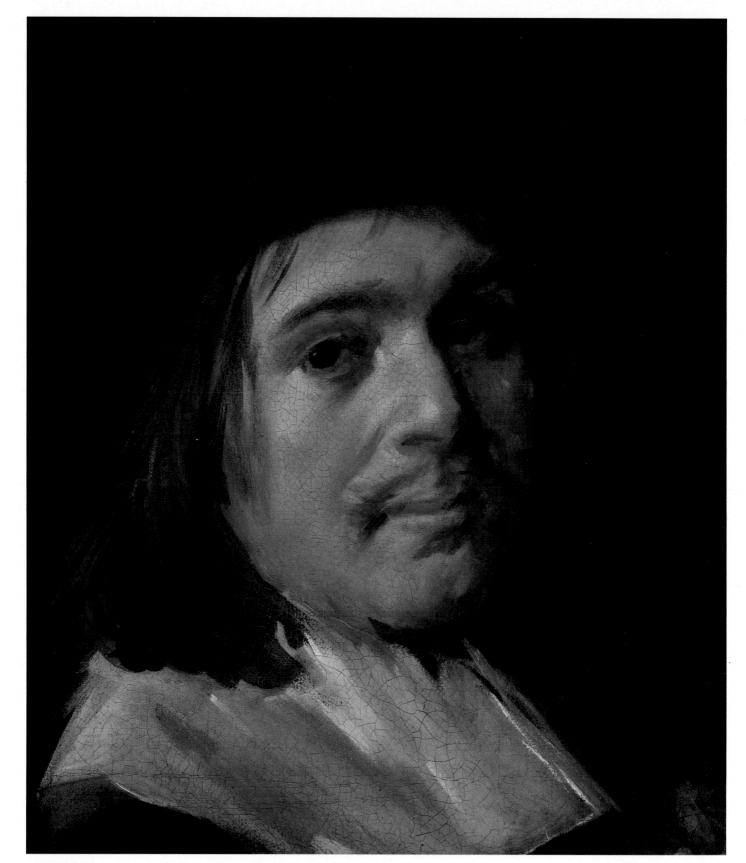

36. Detail from the *Regents of the Old Men's Almshouse* (Plate 42)

37. Detail from *Portrait of a Man* (Plate 34)

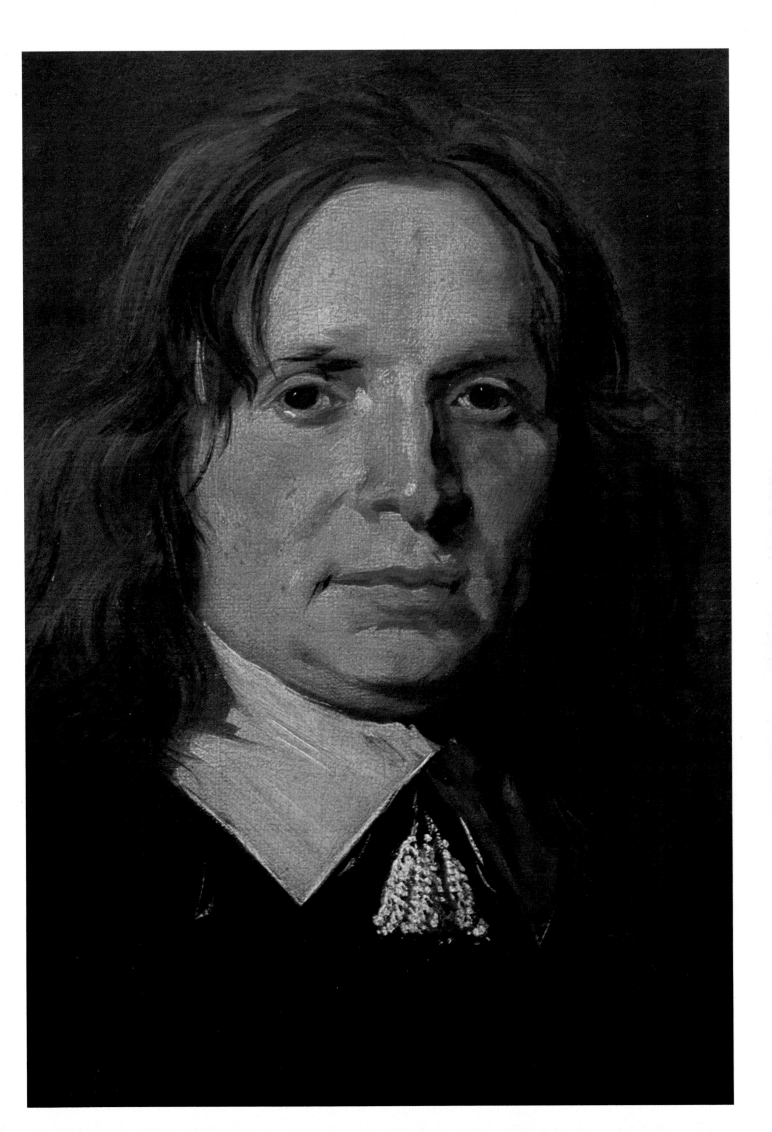

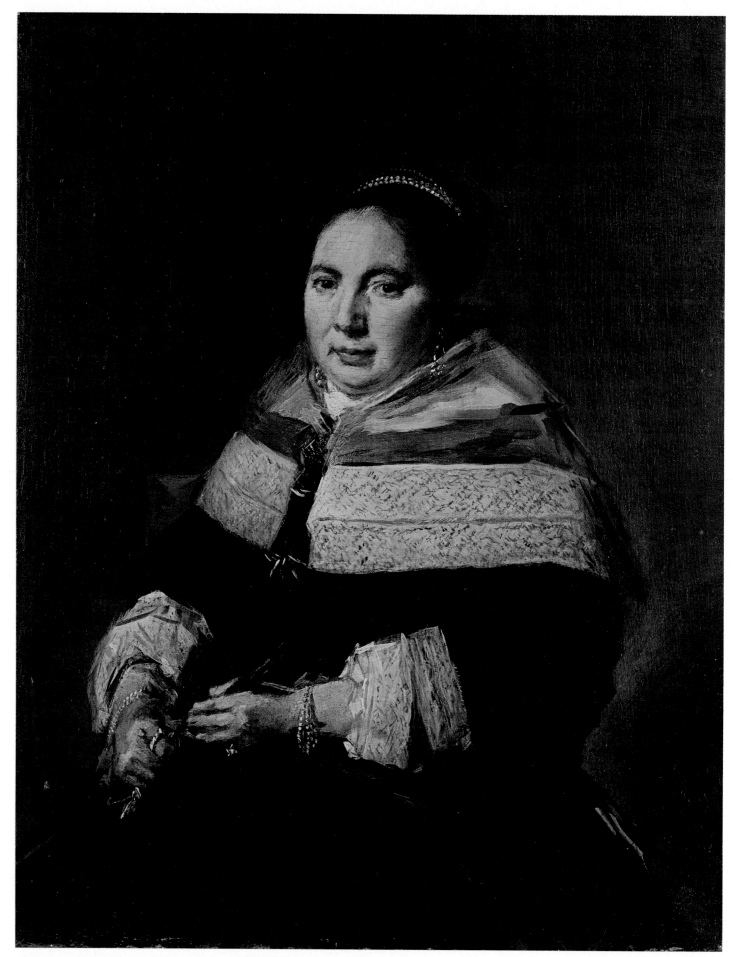

38. *Portrait of a Seated Woman.* 1660s. Oxford, Christ Church

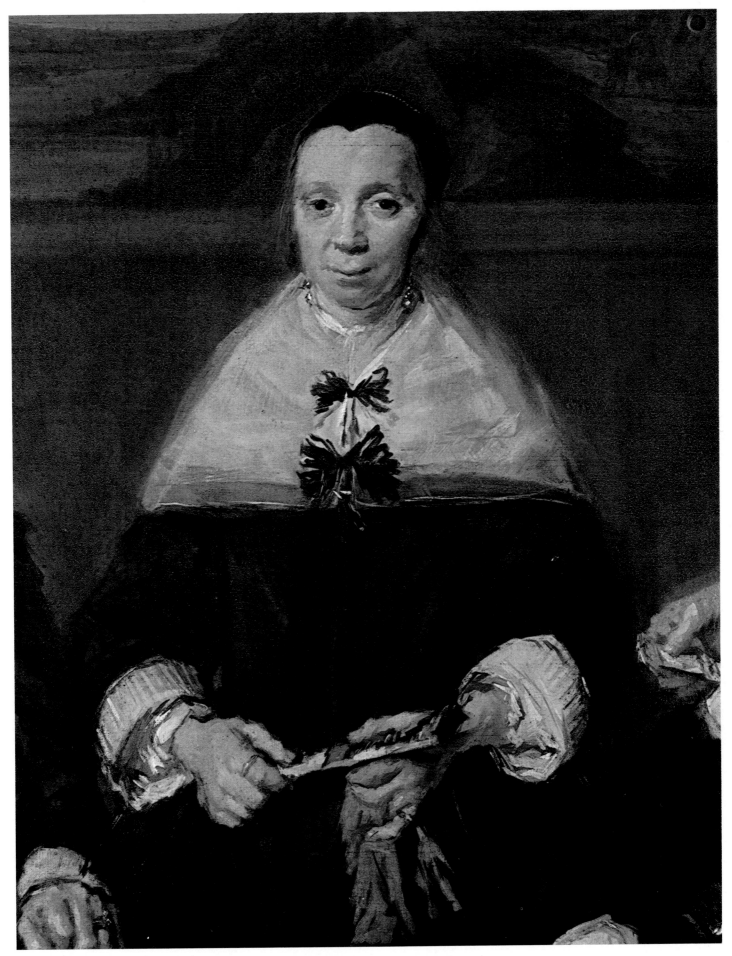

39. Detail from the *Regentesses of the Old Men's Almshouse* (Plate 43)

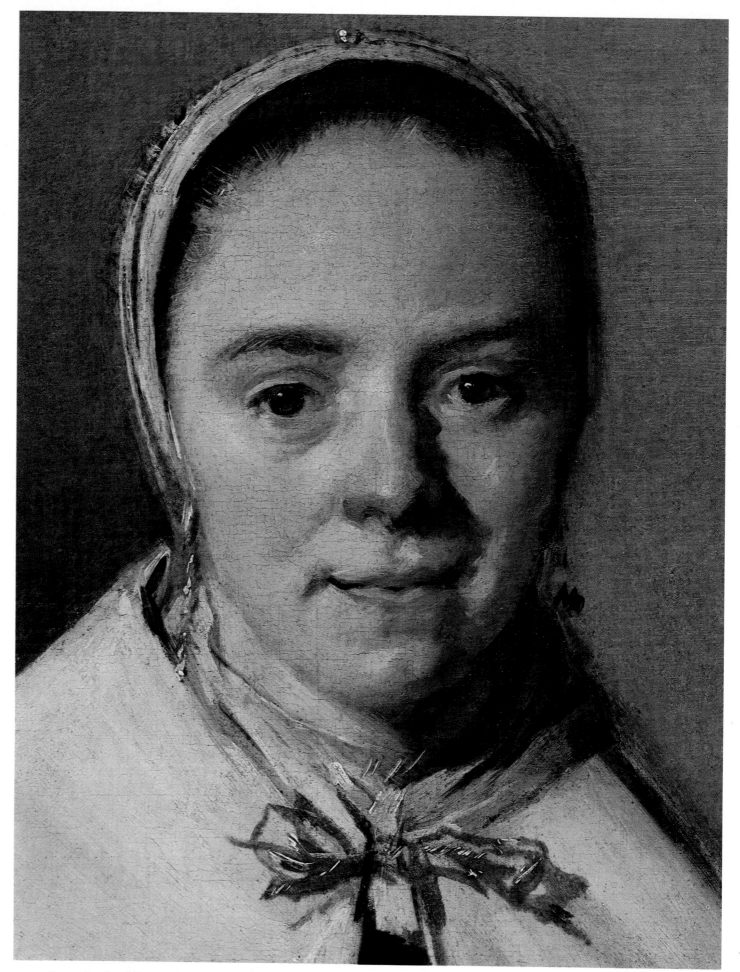

40. *Portrait of a Woman* (detail). Late 1650s. Hull, Ferens Art Gallery

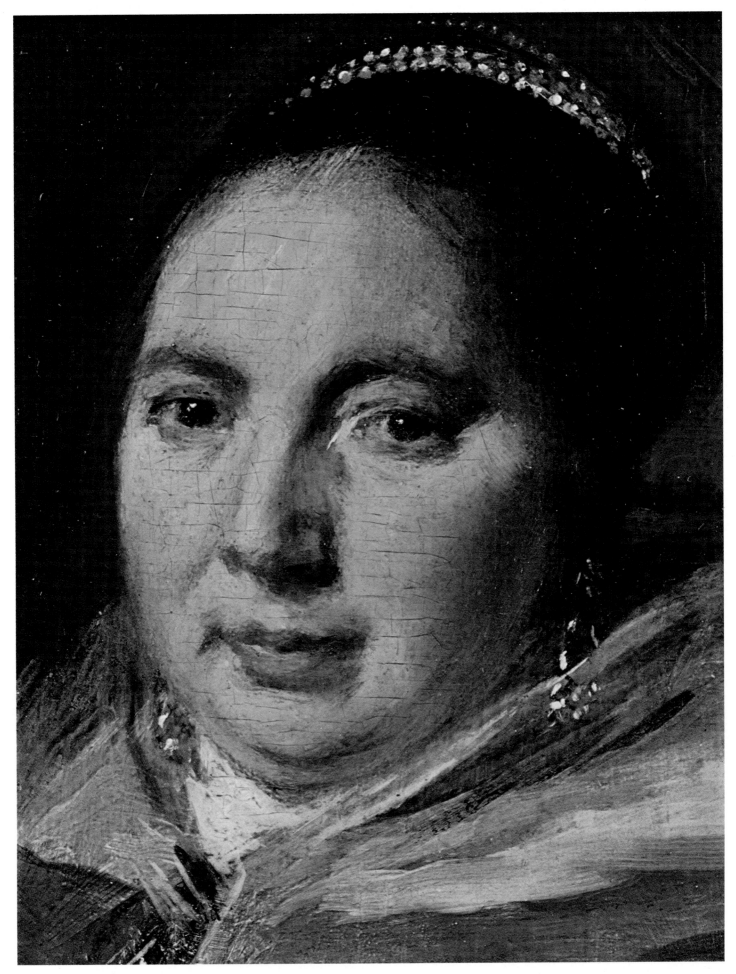

41. Detail from *Portrait of a Seated Woman* (Plate 38)

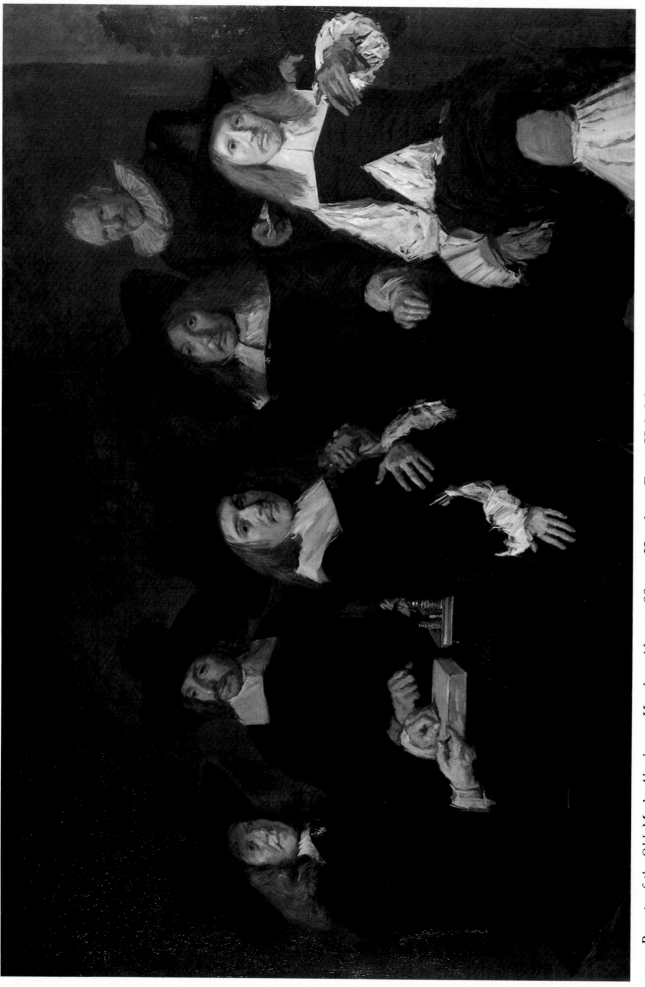

42. *Regents of the Old Men's Almshouse, Haarlem. About 1663–5. Haarlem, Frans Hals Museum*

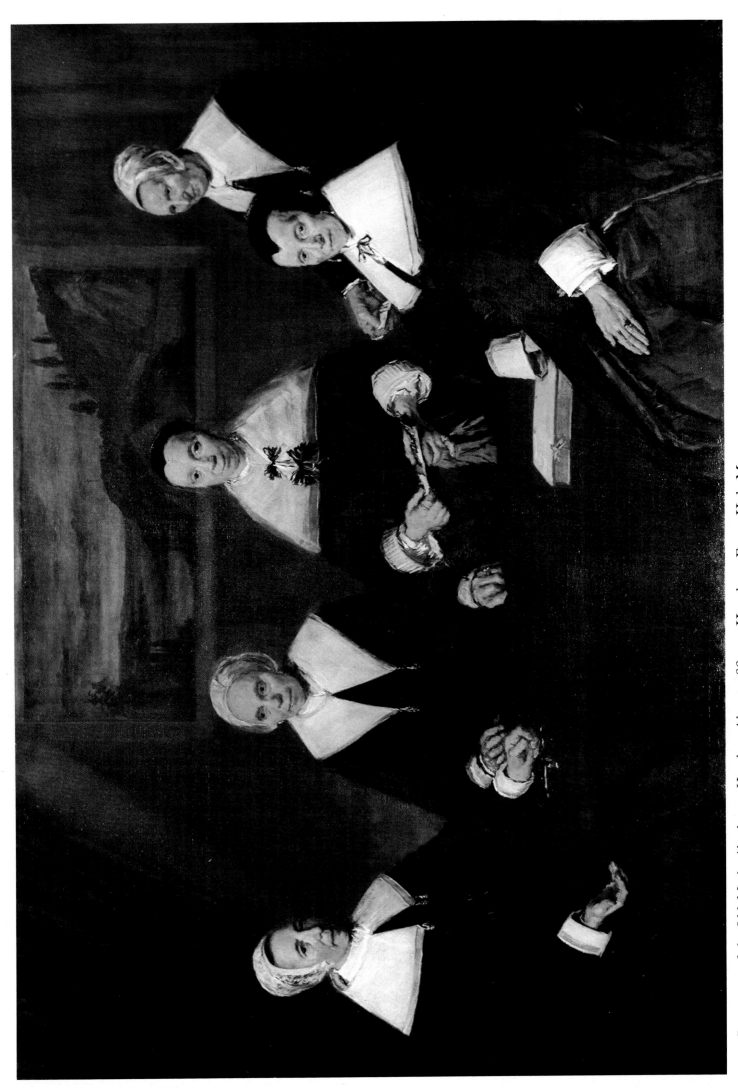

43. *Regentesses of the Old Men's Almshouse, Haarlem. About* 1663–5. Haarlem, Frans Hals Museum

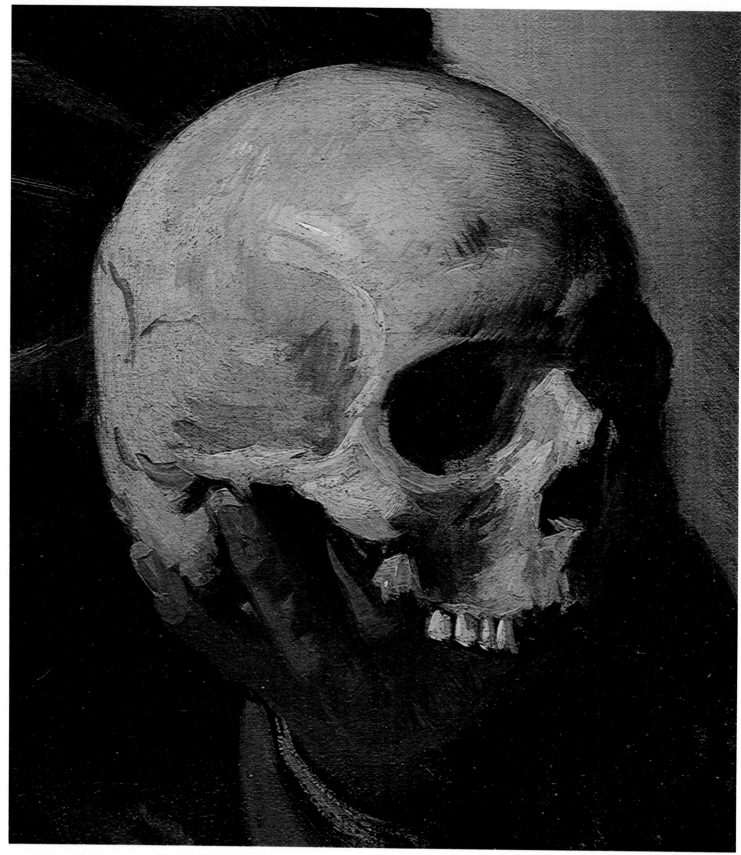

44. Detail from *Boy with a Skull* (Plate 8)

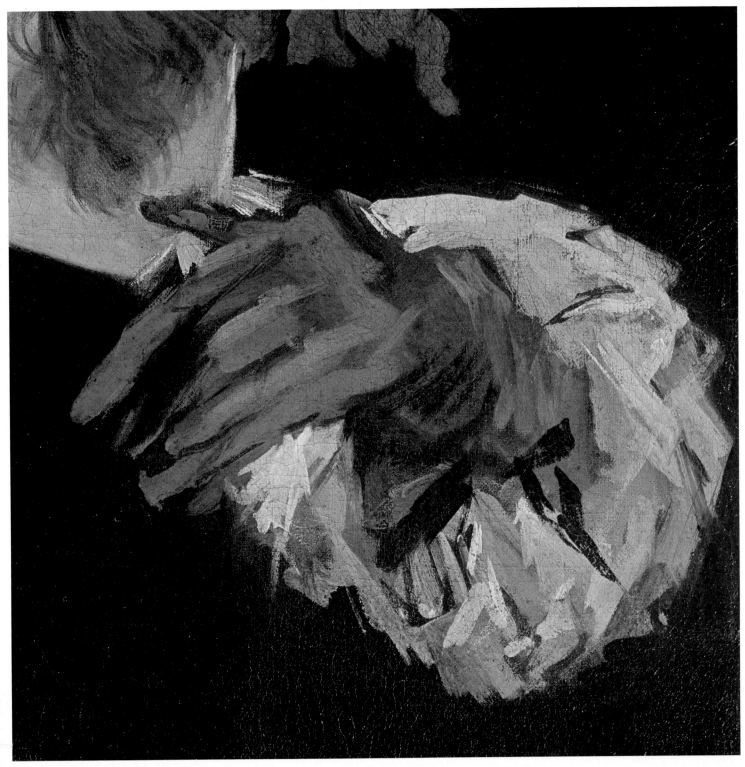

45. Detail from the *Regents of the Old Men's Almshouse* (Plate 42)

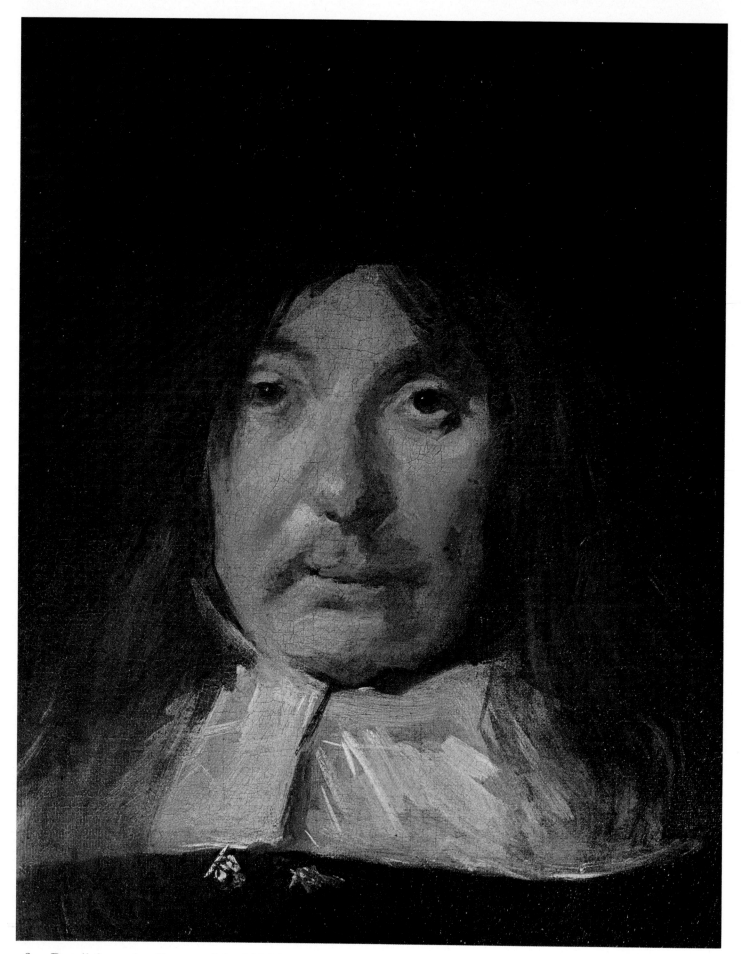

46. Detail from the *Regents of the Old Men's Almshouse* (Plate 42)

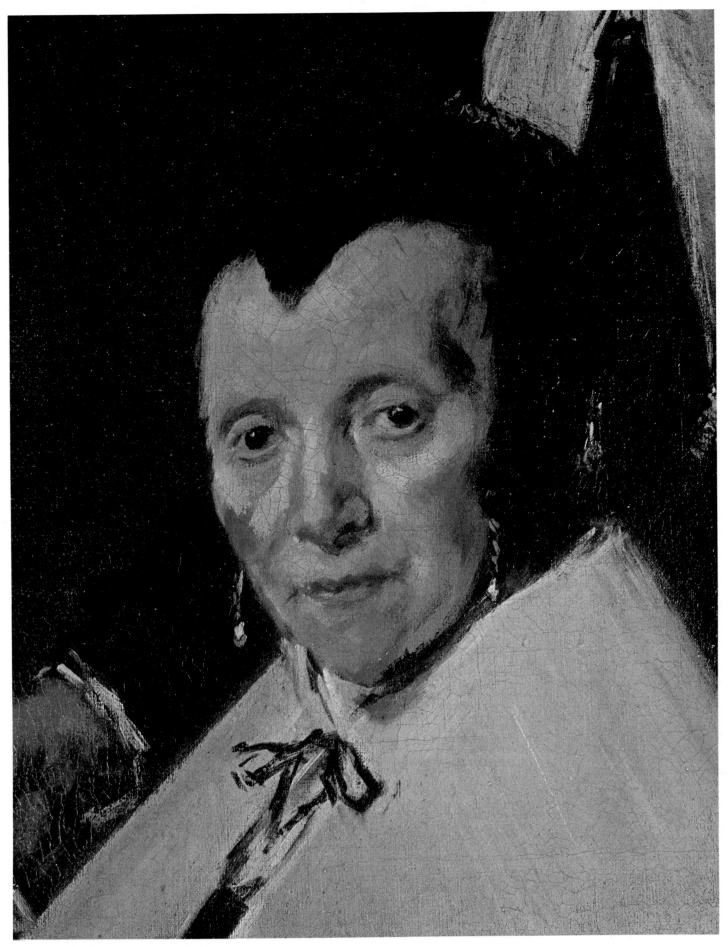

47. Detail from the *Regentesses of the Old Men's Almshouse* (Plate 43)

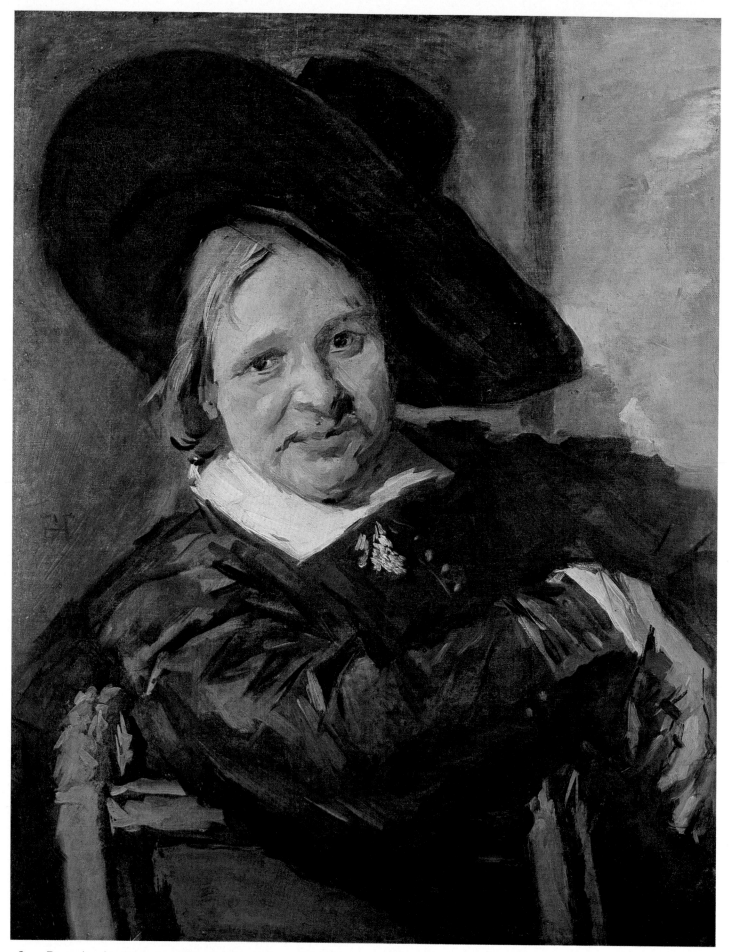

48. *Portrait of a Man in a Slouch Hat*. After 1660. Kassel, Hessisches Landesmuseum